JOHN PIPER

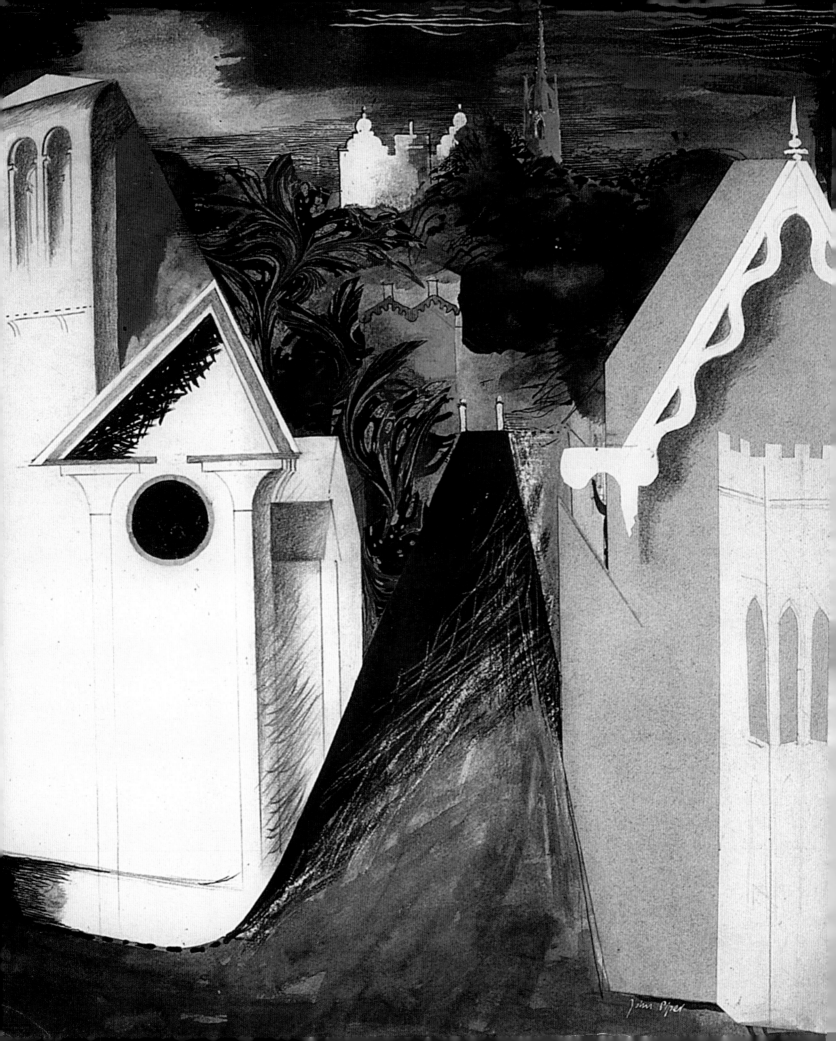

The forties

JOHN PIPER

David Fraser Jenkins

PHILIP WILSON PUBLISHERS

IMPERIAL WAR MUSEUMS

ACKNOWLEDGEMENTS

I am grateful to the late John and Myfanwy Piper for advice and
information over the years. For this catalogue I am grateful to the
Piper family, especially Clarissa Lewis and Sebastian Piper, and also
to John Birt, Jonathan Clark, Caroline Cuthbert, Linda Kramer,
Sir Reresby Sitwell, Neil Wells, and to several anonymous sources
of information. I also thank all the people and institutions who
have lent their works of art. *David Fraser Jenkins*

First published in 2000
on occasion of the exhibition
JOHN PIPER: THE FORTIES

Reprinted in 2013 and 2012 by
Philip Wilson Publishers
an imprint of I.B.Tauris & Co Ltd
6 Salem Road
London W2 4BU
www.philip-wilson.co.uk

ISBN 978-0-85667-534-8

Designed by James Campus
Edited by Michael Ellis

Printed and Bound in China by Everbest Printing Co.ltd.

FRONTISPIECE:
16. *Cheltenham Fantasia (detail)*
1939

TITLE PAGE:
John Piper photograph by
Howard Coster

COVER:
38. *Holkham, Norfolk (detail)*
1939–40

CONTENTS

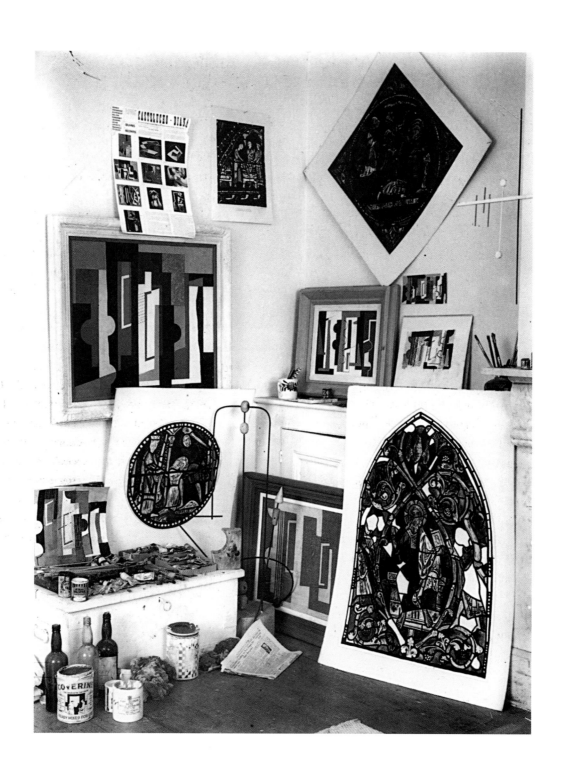

PREFACE

This exhibition is the seventh in an ongoing series of exhibitions devoted to the work of individual artists during the Second World War. These 'war retrospectives' aim to reassemble the majority of an artist's output as an official war artist (something that was never done at the time) and contextualise it with examples of pre and postwar painting as well as other work that the artist may have done outside the official scheme.

John Piper is particularly suited to this treatment, as he was both active and influential in many cultural spheres during the forties, and the foundations of his wide renown were laid during this significant decade. The exhibition focuses in some detail on all aspects of Piper's work, including his architectural paintings, the *Recording Britain* project, his war artist commissions, theatre and ballet designs and graphic work. The Imperial War Museum is not, as it happens, well endowed with examples of his war art – the wonderful paintings of bombed historic buildings in Bath, Bristol and London that you will see in the exhibition were allocated to other galleries in 1946 – although we are fortunate to possess the two paintings of the South West Regional Control Room that are now regarded as important transitional works between Piper's abstract period in the 1930s and his move to neo-Romanticism.

However, John Piper is one of that triumvirate of artists (Henry Moore and Graham Sutherland were the others) who dominate the art of the Second World War and he fully deserves this reassessment of his contribution to British art during the 1940s.

We are very grateful to David Fraser Jenkins, who curated the full-scale retrospective of Piper's work at the Tate Gallery in 1983, for selecting the work for this show and for his informative essay. The artist's family have given their full support. Angela Weight and Roger Tolson have organised the exhibition and supervised the production of the catalogue with Philip Wilson Publishers. Several public galleries in the UK, USA and Canada have parted with their works and once again we are indebted to them for their patient assistance. Piper has always been assiduously collected by private individuals, and we are especially grateful to them for lending paintings which in some cases they have only recently acquired. Sotheby's and Christies and several private galleries have been of enormous assistance in tracing owners of works that have passed through their hands.

Robert Crawford
Director General (1995–2008)
Imperial War Museum

The artist's studio
photograph by
John Piper
*c.*1936

*John Piper at
Fawley Bottom
Farmhouse*
photograph by
Bill Brandt
*c.*1944

1. THE PAINTER OF ARCHITECTURE

John Piper was thirty-five when Britain declared war on Germany in September 1939. A person's age at such a time had a critical effect on what was to happen to them during the next five years, and for an artist the precise nature of his or her career – whether they were committed to a particular way of painting, or range of subjects, or to certain patrons or galleries – was equally a determinant. Piper had only been a schoolboy during the First World War, but his entire family had been affected by the death of his eldest brother in the army. Now, at the outbreak of the Second World War, it happened that he was at the right point in his life to match the emotional burden of his painting to the requirements of being an official war artist, commissioned to make pictures of bombed historic buildings.

In 1939 Piper was already old enough to have earned a reputation as a leading artist of the avant-garde in London, even though he was still near the beginning of his career, since he had become an artist only after a false start that stopped just short of his taking articles as a solicitor. He followed a hurried course as an older student at the Royal College of Art in 1928–29, and then, whilst earning a living as an art critic, educated himself over a four-year period in the early 1930s to a first flowering as an abstract artist. For Piper these few years of abstract painting were still a time of learning, and he never responded to the mystique of abstraction, which had seduced a number of artists while this unfamiliar practice was still a kind of international secret society. At the close of this education – the years just before the war – he was ready to move in whatever direction he chose. However, he remained committed to the subject that had first led him to the arts, the recording and understanding of architecture. All through his life he studied with intensity the buildings of Britain

in their topographical settings, searching for the appearance, history and most individual characteristics of particular places and certain kinds of architecture. More powerfully than any other British artist, at least since Turner and Cotman, he possessed a personal vision of architecture that transformed what he saw. He sought out provincial buildings of extraordinary character, and represented them by his own means of pictorial design, colouring, illumination and texture, turning them into reflections of a unique personal attitude. It was as a painter of the buildings of Britain, while developing the language of an abstract artist, that Piper succeeded in the role of popular war artist.

It is not always easy today to visit a building painted by Piper since, with some ready exceptions such as the ones he was commissioned to research, like Windsor Castle, he usually selected places that are slightly out of the way, just over the brow of an accustomed route, or at least a good distance from towns. At first, it is often remarkable how little the buildings look like his pictures of them, even allowing for changes over the last half century. Their real colours are not as high keyed as in his pictures, and the buildings are frequently more bland, and less craggy and shadowy. They may be more complex and detailed in reality, but the lighting will not be so dramatic and the sky above may be lighter. This is partly because he favoured decaying buildings, which have usually been tidied up, if not entirely replaced, since the time he painted them, but it is also due to his powers of observation. The viewer's eye may be led by Piper's guidance to witness a transformation. This is not a pretence. Such a transformation was suggested by his patron during the war, Sir Osbert Sitwell, who, having driven Piper to look at some castle or ruin near his house in Derbyshire, would sometimes stay to watch him work.

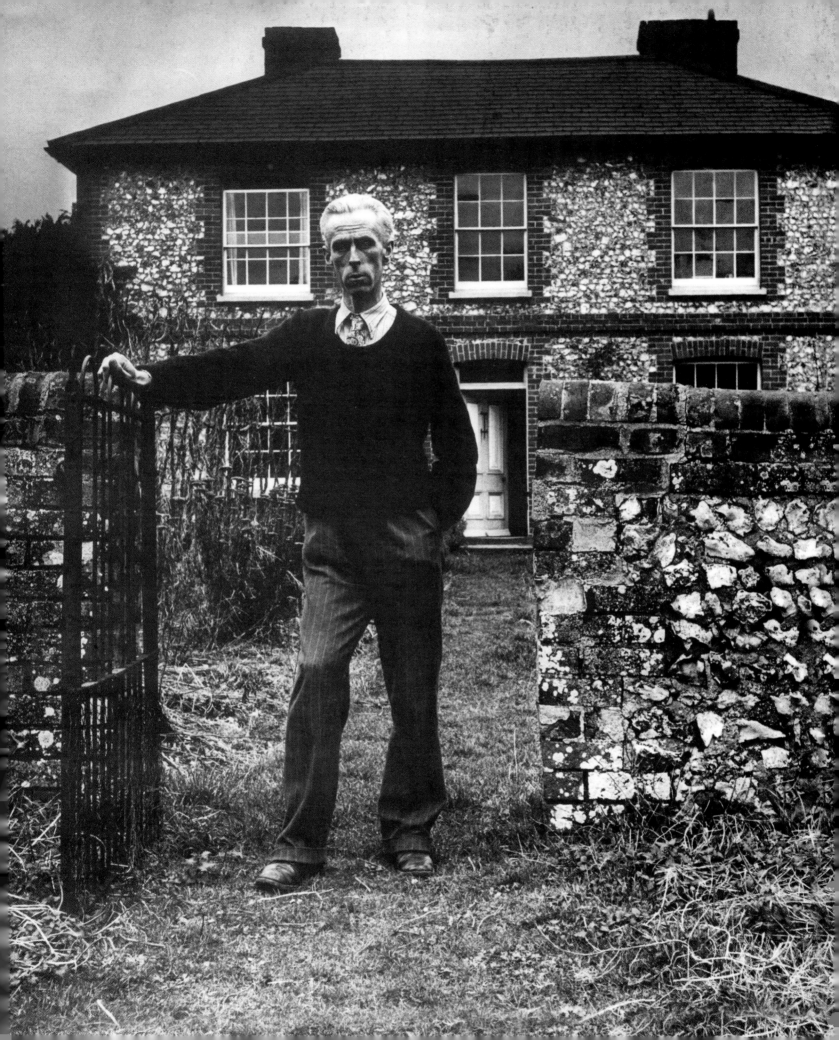

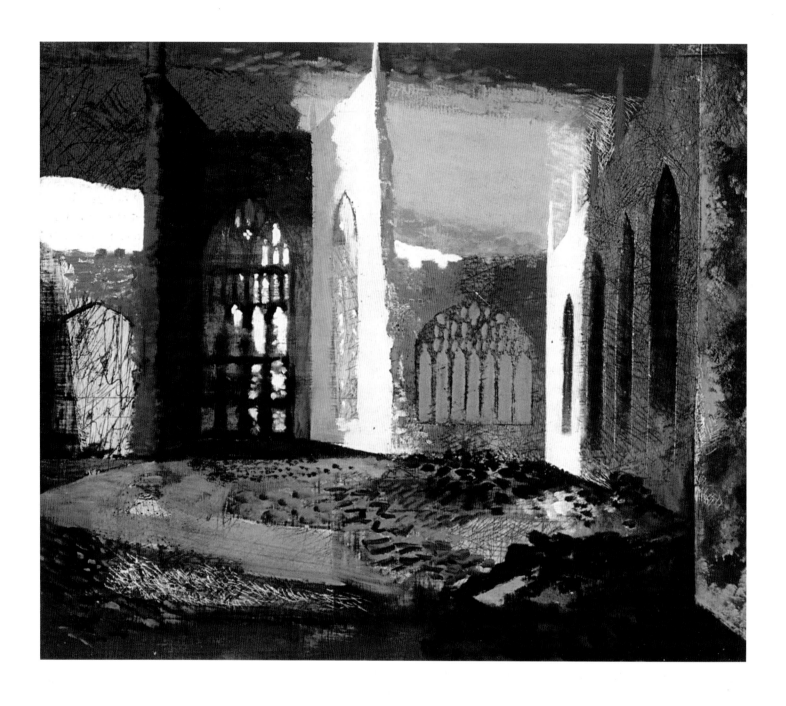

23.
Interior of St Michael's
Cathedral, Coventry,
15 November 1940
1940

Sitwell described, in his own excessive language, how he had witnessed a sudden darkening of the sky one September afternoon (probably in 1944) while he watched Piper drawing an Elizabethan house. Sitwell reveals, in effect, how unusual it is to stare at the light on a building for a length of time, particularly before rain, and concludes that in fact the real skies 'are blacker than he paints them'.[1] Piper actually came to see the intense colours that he painted, and selected subjects where he was likely to find the light and shade that he preferred. Details or colours that look as if they have been altered by his vision are usually the result of his emphasis or visual acuity rather than his invention. The likeness of his buildings is the likeness of a portrait, which resides partly in caricature (by emphasising a few characteristic features) and partly in his grasp of simplified, formal shapes.

Piper was an ideal artist to choose to make pictures of the destruction of British cities during the war. For what he produced was a record not so much of what Coventry Cathedral and the rest really looked like, which was already much published in photographs, but of how a certain kind of British person felt about these newly made ruins at a time when Britain was isolated from the rest of Europe. His paintings are modest, in size and in drama. They are rarely melodramatic, and now look conservative, but at the time their style was regarded as uncomfortably modern and distorted.

During the war it seemed that the photographs in newspapers had caught up with the latest art. Piper felt this himself, in that the transformation he had wrought in his views of historic buildings was now being performed for real by the war. After he had painted the ruined country house of Seaton Delaval in 1941, he wrote in a literary magazine that its destruction twice by fire, in 1752 and 1822, had made its colour 'extremely up-to-date: very much of our times'.[2] It shared a similarity with the buildings that had been bombed, and it was as if both the historic and blitzed ruins were a new kind of modernist building. It is in this picture of Seaton Delaval that the strong reds and blacks that build up the structure of his work are most firmly bound into the architecture of the country house he was painting. He elaborated this in a fantastic way in his essay, suggesting that the house was actually alive, and coping with the roles forced onto it through its history, including being the subject of his picture, implicitly gathering his colour around itself, and emerging finally into 'our own arid, military times'. To the public Piper's art remained extreme, and was still even considered abstracted. Nevertheless, it was increasingly regarded as appropriate for the times.

John Piper
photograph by
Ida Kar
*c.*1954

2. ABSTRACTION BECOMES A PLACE 1936–38

During the years before the war, Piper turned from painting abstract pictures to painting landscapes. The change went through deliberate steps, and in his first exhibition he hung landscapes and abstract works side by side, to show that they were equivalent to each other. This development was in part a response to the expected war, as well as to his wish for his art to move on, since the political context made abstraction seem inadequate, and he felt strongly that there was a need for an art of reconstruction.

Piper was in a position of some freedom in the late 1930s, although it was not easy for him to earn his living from the arts. He and Myfanwy Evans had married in 1937, and they lived in a former farmhouse in the country near Henley-on-Thames. This was Fawley Bottom, a remote place in a valley of the Chilterns, which had no electricity (they went through the war without a wireless) and had only just got running water. There were extensive farm buildings, but Piper's studio was one of the old ground-floor front rooms of the farmhouse. Their first child, Edward, was born in November 1938.

Despite the fact that his parents had been quite rich, Piper lacked money, since his refusal to join his father's firm of solicitors in 1926 had cut him out of his inheritance. He did, however, receive an allowance from his mother, who had also bought the farmhouse for him. Myfanwy was a writer and, with the help of Jean Hélion in Paris, had started the magazine *AXIS* in 1935 to publish articles about the new abstract art. Piper continued to write criticism, in the *New Statesman*, in *The Listener*, in the *Architectural Review* and wherever else he could find a publisher. Their circle of friends, which meant much to them, was gradually enlarging beyond the arts to include writers, musicians and

theatre people. They were both involved with the Group Theatre, which initiated the start of their lifetime collaboration with Benjamin Britten. In the mid-1930s they went regularly to Paris, where they knew Alexander Calder (who lived alternately in America and France) and Jean Hélion. If anyone had asked Piper who were the artists he then most admired, he would most likely have said Turner and Picasso, for, although a committed modernist, he felt no break from the old.

Piper was also a compulsive tourer of the British Isles and had owned a car since leaving art college. He often went to the south coast, and had visited much of the south of Britain since the time when, in his early teens, he had compiled some precocious but elaborate guidebooks to buildings seen on holidays. Travel between Fawley Bottom and London was by train, however, and he would leave his car or bicycle at Henley station. Myfanwy did not drive, and went by pony and cart to and from Henley.

The painters and sculptors of the abstract movement in Britain mostly approached their work through still life or landscape, simplified into some kind of geometry. Piper, like Ben Nicholson, the leader of this group, had sometimes made pictures simply in terms of design, by deliberately contrasting colours or shapes, and starting with no more than these basic elements. But Piper had also begun with real things that he cared about – drawings of a girlfriend naked on the beach, or the patterns on Saxon fonts, or the colours of medieval stained glass. He made and photographed some free-standing painted sculptures, one of them called *Beach Object* since it echoed painted buoys and striped beacons. Looking at this sculpture invited a play between the perception of real and imagined spaces. His large painting *Forms on a Green Ground* (1936–37) has a spatial feel of overlapping screens, some on diagonals, some curved, which cannot

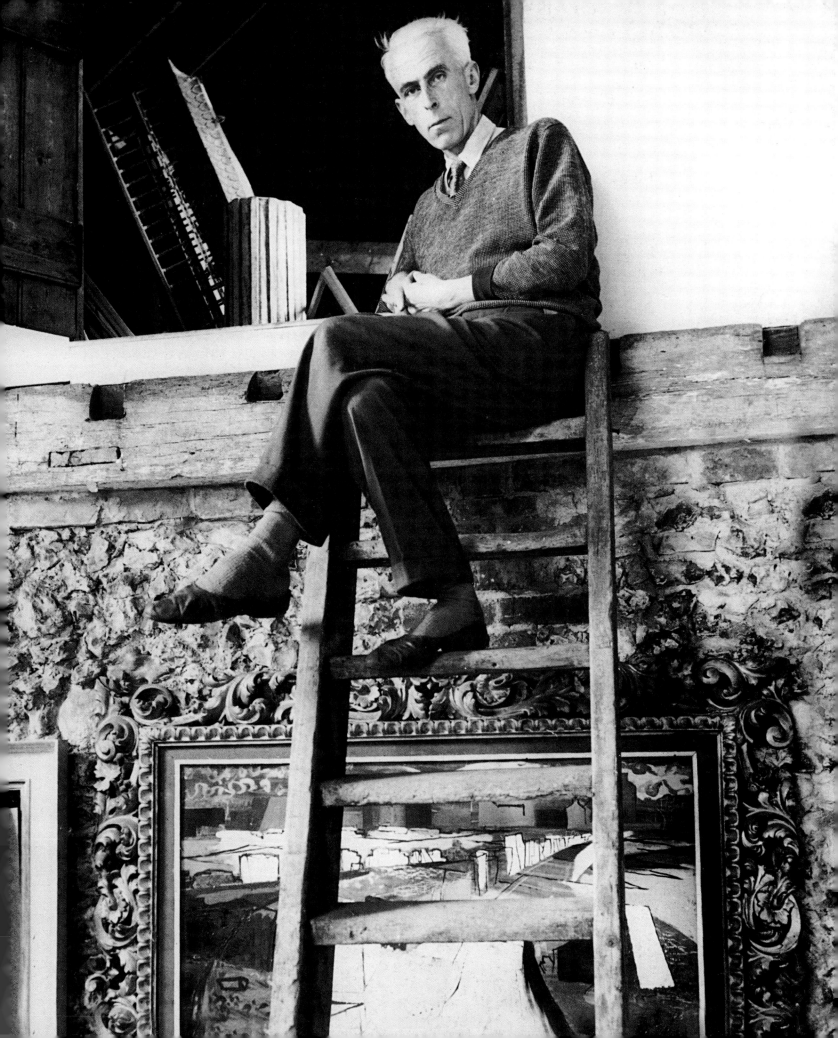

be knitted together to make a real object, particularly as some edges are loosely brushed. The colours are no longer simply the primaries, and the grey-green background is suggestive of a landscape. *Forms on a Green Ground* was one of the last of Piper's large abstract paintings. His own written criticism, however disarming or allusive, regularly explained exactly what he was doing, and his article *Lost, A Valuable Object*[3] describes brilliantly the mental and visual process of finding real space within abstraction.

80.
*Stained Glass
Window Sketch*
c.1936

Piper was given the opportunity to return to an early interest of his, the study of English topography, through a new friendship. He had met John Betjeman early in 1937 in the offices of the *Architectural Review* when he had called to see the editor James Richards, an old friend. Betjeman was then known as much as an architectural critic as a poet, although the two things went together, since his literary portraits were often given a particular point by the character of the rooms and towns of their setting. Myfanwy and Penelope Betjeman had known each other while at school, and the two couples became close friends. Betjeman had initiated, and then continued to edit, a series of architectural guides to the counties of Britain, under the sponsorship of Shell Mex, who were naturally happy to encourage people to use petrol when driving around to visit the places mentioned in the guides.

Betjeman had written the Shell Guides to Cornwall and Devon himself, and had asked artist and writer friends of his, such as the brothers Paul and John Nash, to write others. His idea was to find an artist's view of what was worth a visit, without being either too antiquarian or too anecdotal. Some of the published results were rather eccentric. He asked Piper to write a guide, and they chose for his subject Piper's neighbouring county of Oxfordshire. The book was officially commissioned through Batsfords in April 1937, and Piper finished it by the following November, after travelling around systematically to see the places and take photographs. This marked his return to looking at English architecture, seriously and critically, village by village, and taught him how to write about places in a way that would encourage people to visit and appreciate them. Most of the published photographs were his, but there were only two pages of Piper's drawings reproduced, in a scraperboard white-on-black outline, including several views of the ruined manor house at Minster Lovell. He also stuck together a collage of place-names and typography for the endpapers, but all this interest in the countryside was still peripheral to his practice of art.

Oxon, title page
1938

AXIS 8, cover
1937

4.
Oxon, endpapers
1938

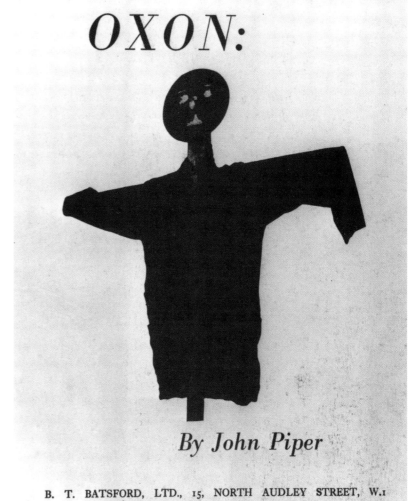

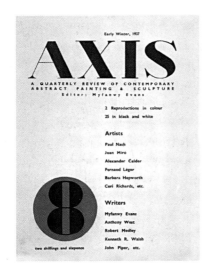

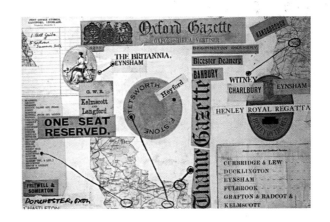

Myfanwy Piper's magazine of abstract art, *AXIS*, did not continue after the eighth number was published in the early winter of 1937. There was no longer a belief that abstract art was the art of the future. The last issue included Robert Medley's *Hitler's Art in Munich*, his account of the 'Approved' and 'Decadent' exhibitions in Germany, which he had seen by chance. Although Medley was shocked by these developments, he still seemed to hope that they could be ignored. Piper's own writing was directed at enlarging the context of modern art. His essay 'Pre-history from the Air' reproduced aerial photographs of Beacon Hill in Hampshire and the White Horse at Uffington, and he argued that the 'change in consciousness of space and vistas' links this aerial view of a British primitive art with modern art such as a paintings by Miro.[4]

Similarly, in 'The Nautical Style'[5] he suggested that the design of lighthouses is an argument for function-alism in architecture, noting that the Eddystone Rock lighthouse of 1759 was far ahead of its time – that is to say modern – in its simple shape and rejection of ornament. This article was also a bravura display of his knowledge of provincial buildings, and a passionate accolade for the coast – 'England's coast is its most important feature'. Piper's belief in the significance of the seashore goes beyond the observation that coastal buildings look modern. Although it is not explicit, it seems now that he saw Britain's coastline in 1937 as the point of transfer between Paris and London, where the fragments of abstraction might be rebuilt into some-thing new. Everyone knew the political dangers, and the coast was the home side of the last ditch.

Alexander Calder came to stay at Fawley Bottom in the autumn, while making sculpture for his exhibition at London's Mayor Gallery in December. He brought with him his model *Circus*, and put on a show in the house during a social gathering of modern artists and writers. The *Circus* illustrated Calder's easy move from the pure abstraction of his mobiles to the similarly designed shapes that represented the toy animals and clowns in his stunningly inventive performance.

The first post-abstract pictures that Piper completed for exhibition were some collages, put together out of doors in Southwest Wales in February 1938. They were pictures of the deserted, cold, stormy margin of land and sea, but they were more than a simplified effect of space, looking across a bay or over shingle under a cloudy sky, since each had a distinct sense of being a particular place. He made these collages directly on the beach, from coloured papers and printer's surplus, which he tore into shapes and stuck on with glue, sometimes drawing over the paper in ink. He never – or at least very rarely – used oil paints out of doors, but would sit and draw in front of his subject using a drawing board large enough to take 22 x 28 inch sheet of paper. With the board perched on his knees or on top of a wall, he learnt to cope with ink and colours in wind and rain. On this February visit, driving around with Myfanwy in his old Morris, he also used the collage technique as a means to visualise and record a type of architecture. In the pages of a sketchbook he made a number of small collages of Nonconformist chapels in Cardiganshire and Pembrokeshire.

Piper saw these landscape collages as equivalent to his most recent abstract pictures, as he told Paul Nash, who wrote the introduction to his first one-man exhibition, held at the London Gallery in May 1938:

The first remarkable feature of this exhibition, from the spectator's point of view, is that so-called 'abstractions' and pictures of a representational kind are shewn side by side. Beyond this even, both are given nearly similar titles. This is not, as some may suspect, a new perversity; rather, it is a concession on the artist's part. He would like it to be evident, that although the solution of his equation is in 'abstract' terms, the features of his design retain the influ-ence of association. They are not resolved beyond the reach of a normal, sensitive, nostalgia.[6]

Also shown in the exhibition were photographs listed in the catalogue as 'scenes from *Trial of a Judge*, by Stephen Spender, produced by Rupert Doone for the Group Theatre'. Piper had designed an abstract set

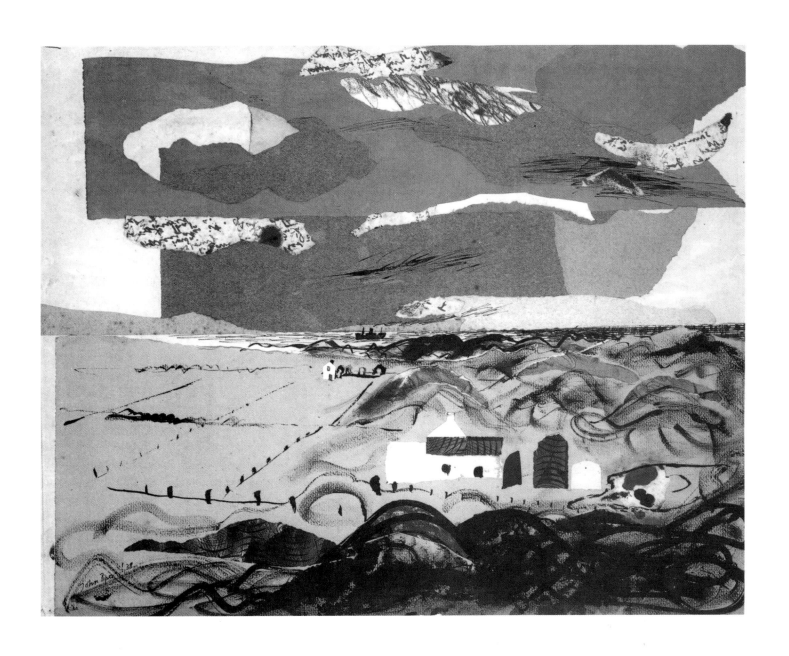

3.
Pendine
1938

for this verse play. Spender's story was based on an incident in Germany in 1932, in which a local Nazi party had pressurised a Judge to acquit some of their members who were being tried for the murder of a rival Fascist; the Judge had complied, only to be later condemned and executed by the Nazis. The writing was abstracted in the sense that it was about the ideal of Justice, and the play was performed in stylised movements, hence the need for abstract set designs. Piper and Robert Medley together painted the sets for the tiny theatre near Euston. The primary colours and the arrangements of rostrum and flats were not only appropriate to the idealism of the play, but also had a dramatic role. The modernist room created on the stage – comparable to Mondrian's studio in Paris, which Myfanwy had visited and admired in 1934 – was shown to be an example of self-indulgence and an immoral escapism. At one point in the play the set represents the Judge's home, which the Nazi Home Secretary visits. Demanding an acquittal, he shouts at the Judge:

'Trial for a Judge'
photograph by
Humphrey Spender
1938

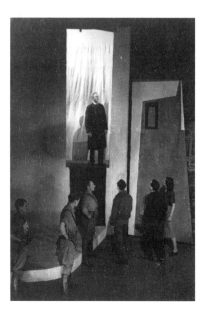

You seem to forget that the law is intended to protect the State from enemies and not to fulfil an abstract ideal of justice ... here you sit fidgeting at jig-saw patterns in this white, square room when, outside, all the world in crisis shoots up to a prodigious firework.[7]

That square, white ideal had only recently been quite good enough for the most modern artist, but although it was still correct as an ideal, it was now inadequate. This is according to Spender's text, but by then these views were widely shared and are probably reflected in Piper's set designs.

There is again a political context in an article by Piper published in July 1938, in which he takes for granted that war is coming, and more forcibly condemns the practice of abstract painting. He asks artists to be ready for a 'reconstruction' after the war, which he suggests could begin with the empty scenery and scraps of litter seen on the English coast. He is describing his own new pictures, one of which was reproduced on the same page in the magazine. Art since Cubism, he wrote, had left the visible world shattered, but it could be put together again in a new way from its simplest parts – from the bare shapes of the coast, for example, and the traces of human life in tidal litter:

For the shattering of the picture by Picasso *et al* was itself symbolic of the world earthquake. War and Air-Raid Precautions are refuges, not remedies. Ways out, not ways through. It is far better, though far more difficult, to begin to build again. That is a difficult ideal: one that must be *approached*, and that cannot safely be pre-conceived. The thing for painters to do is to be prepared: not for war but for work. Not Air-Raid Precautions; reconstruction precautions. If by a fluke there should be no war painters indulging in luxuries like abstraction and surrealism will not be ready. ... Pure abstraction is undernourished. It should at least be allowed to feed on a bare beach with tins and broken bottles.[8]

This infatuation with the coast of Britain, coupled with Piper's interest in old guidebooks, which he was

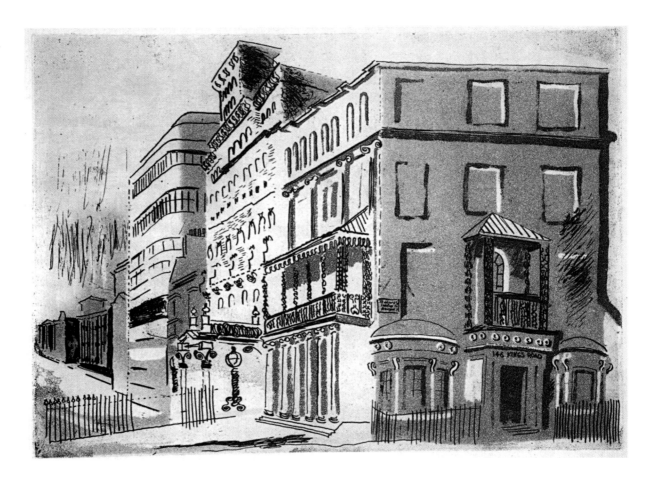

beginning to collect seriously, led him to a further
revival of a forgotten English art. He drew a set of
twelve *Brighton Aquatints* in the autumn and winter of
1938, and published them as a book with an apprecia-
tion of each place. The aquatinted view-picture was
a forgotten art of the 1790s. This was an exercise of
learning for Piper, both in how to make these prints
(he went back to the Royal College for some private
lessons) and, more importantly, in how to look at build-
ings. He walked around Brighton with James Richards,
and did the technical work with Oliver Simon at the
Curwen Press, which had already published some of
his essays in the magazine *Signature*, and with Mervyn
Horder at the publishers Duckworth.

The prints are deftly witty, and were instructive for
the scratchy, summary line of etched detail that the

aquatint process demands, although this was a style
that he would only ever use again when producing
topographical drawings for other guidebooks, or for his
personal notes. The aquatints are memorable for their
caricature of each Brighton landmark, an attitude that
the eccentric architecture of the town encouraged.
There is also something of the nursery about them –
appropriately, as they were made at the time of the
birth of the Pipers' first child. One print shows the
modernist Embassy Court flats alongside their neigh-
bours in the street, each building appearing to be totally
different, and yet all belonging together as inevitably
of their period. At the same time he made drawings
of Brighton and Hove in preparation for paintings.

3. BUILDINGS WITHOUT SIGHT 1939–40

Almost everything that Piper drew, photo-graphed or painted in 1939 was of a building, even if seen only at the far end of its own particular landscape. He pre-pared a second Shell Guide with John Betjeman, this time to Shropshire, and wrote exten-sively on architecture for James Richards at the *Architectural Review*. His work on the *Brighton Aquatints* had focused his attention on the character of clusters of buildings in towns, which led to some new paintings.

A painting he made at Fawley Bottom in the winter of 1938–39 of a street in the Kemptown area of Brighton was something of a breakthrough, and sug-gested a direction for many of the paintings he was to produce in the following years. It was distinctly an experiment, and idiosyncratic in colouring and tech-nique, but the most remarkable thing about the painting was that he chose to depict a row of houses that seemed to have no windows, or at least windows that were entirely shuttered. The street was painted as if seen after dark in winter, but the essential import is confirmed in the title *Dead Resort, Kemptown* which is not, as usual for Piper, just the name of a place, but is descriptive of its character. The houses are isolated and blind. Piper's buildings sometimes look like abstracted faces, and in this case they are faces that are unable to see. This tendency carried on through a series of paintings for more than a year, so that his 1939–40 view of an ordinary pub in Windsor, the Royal Adelaide, again quite bizarrely had no windows. This painting looks particularly like a face, with a nose and an open mouth. The churches and chapels that he painted, such as *Gethsemane, Cardiganshire* (1940), some-times had their windows clearly plastered over with the same material as the wall beside them. The meaning of the blank windows is not explicit, but these sightless eyes have the feeling of a pre-war mood: defenceless, threatened and unable to respond.

In technical terms *Dead Resort, Kemptown* exploits the contrast between the weave of the linen canvas and the partly exposed polished surface of the wooden panel that the material is stretched across, maximising the contrast of textures and lighting on the different build-ings. As with some of the aquatints of Brighton, Piper foreshortened his design along a diagonal. The oblique angle became one of his two preferred views, along with the directly frontal, as he tried to simplify the design of his pictures as much as possible. The painting of Kemptown was exhibited in *Artists of Fame and Promise* at the Leicester Galleries in the summer of 1939, and was bought on behalf of the Contemporary Art Society by Sir Kenneth Clark, then Director of the National Gallery. It was Piper's first sale to an institution, and a year before he got to know Clark as a friend. So far as Piper's reputation was concerned, this sale went some way to making up for his second placing in critical esti-mation to Henry Moore and Graham Sutherland, who both sold more readily from exhibitions.

An artist who chooses to paint a pub in Windsor and a Welsh chapel is also demonstrating a particular archi-tectural interest, and Piper and James Richards set out to re-discover nineteenth-century building types. Such 'ordinary' buildings had been ignored, and to survey these by type was a way of writing architectural history without the names of architects, and potentially offered a model for new building. For Piper it was also a means of getting to look at things, as well as providing an income. He was selling few pictures, but for an article in the *Architectural Review* on buildings on 'The Bath Road' he was paid £32, equivalent to the sale of two paintings. This directed looking overlapped with his interest in sketching, and he and Richards drafted a list of future

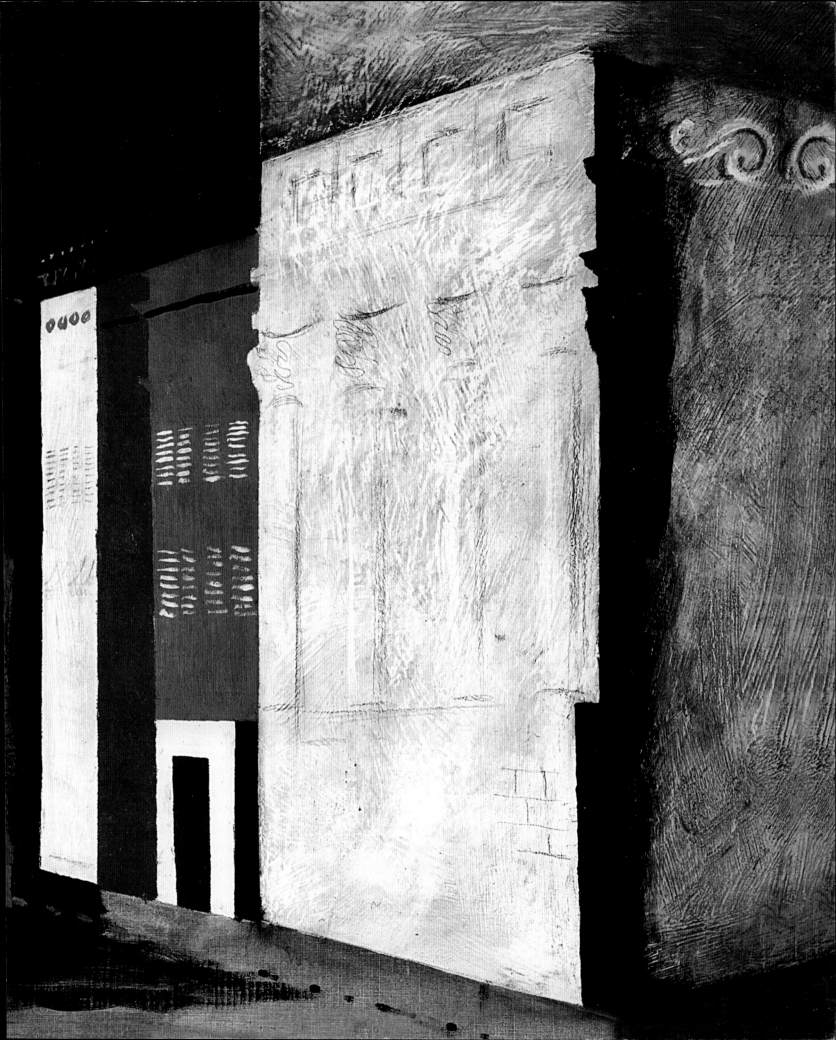

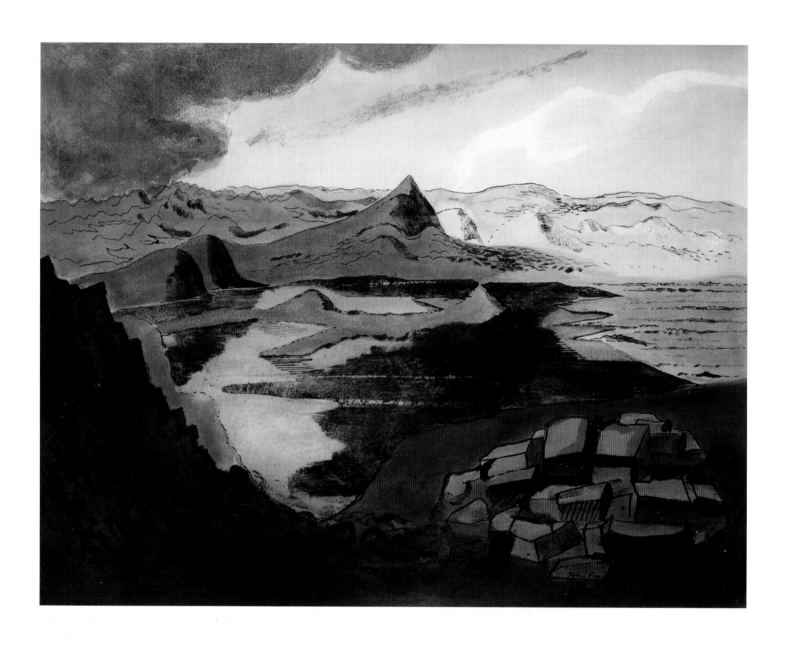

5.
Trawsallt,
Cardiganshire
1939

articles, which included subjects that were already amongst his favourites: 'The Suburb'; 'The Church Towers of Lincolnshire'; 'Toll Houses'; 'Dissenting Chapels'; 'The Railway Style'; and 'A Study of a Hundred Yards of Suburban Road Examined Yard by Yard, including the Pavement'.

The list points towards an unexpected precedent of British art in the 1980s: the pavements bring to mind the sculptures of the Boyle family just as the litter on the beach calls to mind the assemblages of Tony Cragg. In the case of these two artists there is a literalness of object and ordinariness of common life that is appropriate to a political leaning towards socialism. To be on the left politically meant something different for artists of the 1980s than it did in the 1920s when Piper's political commitment was first made. In his case, Piper's political sympathies remained a constant background, and this attitude led him to think of art in terms of the ordinary public. It also it reinforced his dissatisfaction with the highbrow and theoretical.

It was in April 1939 that the first plans were made to employ artists on special work in the army if there were to be a war. These moves came from Paul Nash, who was in a position of experience. In the First World War he had served briefly in the trenches and then, after an accident, had returned as an 'Official Artist at the Front'. During the 1930s he had tried to promote a tolerant approach to the varieties of modern art, staying in contact with younger artists and trying to co-ordinate a common front. His idea now, at the return of war, was to find employment for artists within the services on anything that required drawing and observation. This was in part to make use of their skills, and in part, at the risk of unfair protection, to spare them from conflict on the grounds that they were too important for the country to be lost. To start with, Nash compiled lists of artists, architects, composers, archaeologists and writers. The lists included the names of Piper, Betjeman and others of their friends. Nothing came of Nash's plan, but some of the ideas and names were taken over when the War Artists Advisory Committee (WAAC) was set up in September 1939 under the auspices of the Ministry of Information.

At about this time Piper returned to West Wales for a painting tour. He and Myfanwy left Edward with her family and stayed for three weeks in the village of Pontrhydfendigaid, inland from Aberystwyth. Piper had bought a second-hand Lancia for £60 (which he kept until 1948), and was able to travel with some ease wherever he wanted. He was no longer interested in the coast, and chose this inland village, situated near one of the most desolate areas of Wales, in a deliberate search for isolation. The area of lakes nearby, where he worked, is described in a travel book published in 1931:

> The difficulty of access makes this a very lonely place, rarely visited by any but an occasional shepherd or angler. Many would find its weird solitudes depressing, but those who appreciate such scenery will find it extremely fascinating. There is nothing like it elsewhere in Wales or even in Ireland where somewhat similar country exists, but on a smaller scale. For some 30 miles north to south and from 10 to 15 miles from east to west the "Great Desert" extends and the wildest part of it surrounds these lakes. In its sterile grandeur this strange region suggests some primitive forgotten land.[9]

It was here that he painted mountains and lakes for the first time. With the idea of preserving the flatness of surface of his design he experimented in painting on glass and transferring the result to paper as a monotype print. It is possible that some of these monotypes were made at their bed-and-breakfast lodging in the village. In this desolate place he still wished to indicate a trace of building, and some of his views look across the lakes to a hut. A monotype *Trawsallt, Cardiganshire* shows distant mountains from an unexpected pile of bright red building stones placed in an ellipse in the foreground, there as a token of the reconstruction for which Piper had appealed, and still found in this most empty of places. His art needed to be built again from a place where nothing existed.

The rebuilding that Piper sought was also suggested by a different kind of guide. He wanted to reinvigorate his own art through his direct experience of places that had already been painted by the artists of Turner's era. He trusted historic artists to lead him to what was worth seeing, and liked the idea of a link to the past of a specifically British art. More fundamentally, it seems that he enjoyed the play between an existing drawn design and the same thing in nature that he could see for himself. He told Peggy Angus, the artist wife of James Richards, that one should not be ashamed of 'working in the tradition that seems your natural ancestor' from amongst the artists of the past.[10] He shared this attitude with another friend, the poet, botanist and literary anthologist Geoffrey Grigson. Grigson was a devotee of the modern movement in art and literature, but deliberately shifted ground in the late 1930s to rediscover provincial places and study local poets, especially those of the eighteenth century. He also believed in being guided to the landscape, as a way of returning to a more specific human emotion:

> ... it is curious to see how much the spots in England we
> think especially beautiful gained that reputation for them-
> selves in the past; how much, especially in the eighteenth
> century, our landscape feeling, our landscape anthologising
> (for that is what it comes to) has been done for us.[11]

Piper had seen a copy of John Warwick Smith's huge portfolio *A Tour of Hafod* (1810) and went to see for himself what the estate looked like while he was nearby in Wales. The house at Hafod had been abandoned, and he and Myfanwy broke in and wandered around, finding the ruined garden pavilions and the overgrown remains of what was once a celebrated picturesque landscape. This was the famously hot summer of the last August before the war. He made masses of sketchbook drawings in a flat, pale and rather thin style, similar to that of Warwick Smith. Piper later excluded these works from the illustrations in his 1944 volume of the Penguin Modern Painters. *The Gorge at Hafod* is an oil painting derived from one of these drawings,

showing a view up a stream (which was in fact the river Ystwyth), towards a Gothic folly with arches. There may have been a concealed visual inspiration for this and other drawings of the follies. He and Myfanwy had been bathing naked in the lakes, and there is a suggestion in the contrasts of these pictures that the follies take on the role of a nude in the landscape. If this is so, it is a nude returning to the landscape, since Piper's first abstract painting had stemmed from pictures of bathers on a beach.

The war forced a fundamental change in attitude to Piper's making of art, as it did for many others. Before the war he was independent, and provided he could earn enough he had total control over the kind of work he made. It did not matter in principle whether he was producing paintings for private exhibitions or launching books of prints with a publisher. But all this changed when his freedom was restricted at the outset of the war. At first he was not in danger of conscription because of his age, although it was clear that he would eventually be called up. He did volunteer for ground work with the RAF, as he thought that through the interpretation of aerial photographs he would be able to carry on the kind of work he had enjoyed when preparing his article 'Pre-history from the Air', but his application was unsuccessful. In the meantime he was unable to travel because of petrol rationing, the public art galleries were empty and new exhibitions dwindled while people were too pre-occupied to think about art. Later in the war, however, he received official commissions for paintings from the WAAC, and so was given an audience and a committee of judges. He did not, therefore, have to find his own market or provoke criticism from his peers. The kind of art that he made suddenly became useful and was admired. From being quite well known but only to a very few of the highbrow before the war, he suddenly became popular, a new and unexpected situation.

Two jobs came to him swiftly in the first months of the war. The art critic of *The Spectator*, Anthony Blunt, was called up, and passed on his job to Piper, who

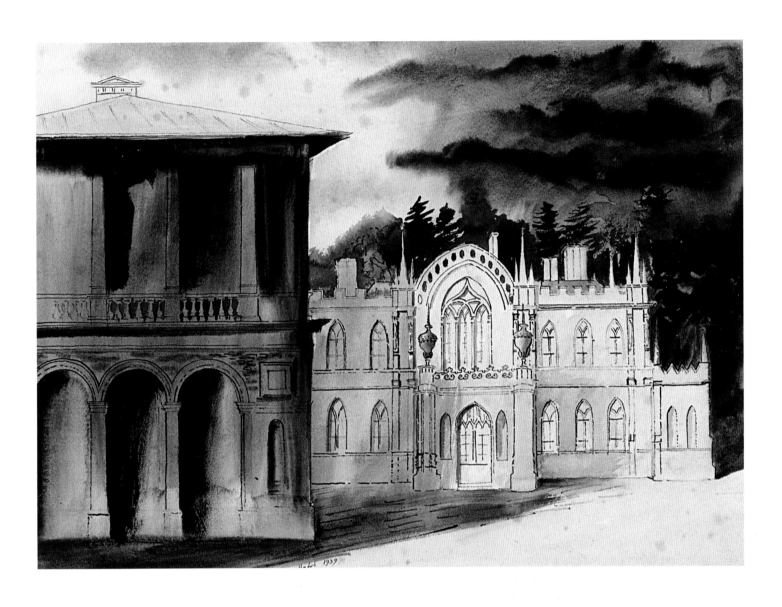

6.
Italian and Gothic,
Hafod
1939

carried it on throughout the war. Then, his first commission of the war came from 'Recording Britain', a scheme that employed artists to make drawings of the towns and the countryside of Britain. This extraordinary project, financed almost entirely from America via the Pilgrim Trust, was launched in October 1939 and directed by Kenneth Clark. Clark had been in touch with Paul Nash, and had also been sent the lists of names that Nash had gathered, including a selection of artists compiled by Piper.

The *Recording Britain* scheme appears to be a first attempt to establish the employment of war artists. Piper was allocated 'recording' in Oxfordshire and Berkshire, and later in Buckinghamshire. He took this opportunity to carry on in the romantic and topographical style of his Hafod watercolours, and in October he arranged to see the watercolours by Cotman that belonged to Sir Michael Sadler, specifically with a view to using them as a model for this commission. By Piper's standards, his results were mostly slight, although useful to him as a way of understanding the powerfully spare designs of Cotman. Piper was regarded as one of the stars of the *Recording Britain* scheme, and one of his drawings, *The Barn at Great Coxwell*, was later a focus of the exhibition *The Englishman Builds* at the National Gallery.[12]

A selection of the *Recording Britain* drawings, which were commissioned from many artists, was exhibited in 1990 at the Victoria and Albert Museum. The reproductions of the best of them in the catalogue for the exhibition are surprising both because they are so competent (without being far removed from illustration) and because the works of the artists look so similar, as if there were a 1940 common style. Nevertheless, the pictures radiate local charm in a way that provokes the suspicion of some universal failure of nerve, since life in the cities was not one of the subjects recorded, and the tenor of the survey now looks more like 'a weather forecast' than 'The News'. Piper was the only pre-war modernist who condescended to take part, and the only one within the scheme whose drawings had any quality

of abstract design. He later said that during the war he felt a responsibility to do whatever was asked of him, but in his case he was not working against the grain.

Piper's first commissioned watercolour of a country house – again for the *Recording Britain* project – was of Buckland House, Buckinghamshire, which he painted in September 1940. The popularity of his topographical work at this time was proven by his second one-man exhibition, held at the Leicester Galleries in March 1940. The show included most of his drawings of Hafod, all of which sold.

Kirkby Hall. Evelyn says "very noble ... built à la moderne ... but the avenue ungraceful and the site naked." Beautifully naked it remains, a yellow, half-ruined palace in a bare wold landscape. Plan preserved in the Soane museum and John Thorpe, the architect, inscribed on it "first stone laid 1570." Office of Works took it over 1930, but has not ruined it. Some repairing work going on, not too much mowing and rolling. The garden house & gates, with heavy mouldings are very effective.

Fotheringhay. The church is like a fragment of a cathedral, chancel destroyed: the enormous nave remains. Pinnacled aisles with slender flying buttresses. The East end, outside, is as good as any decayed English façade: an area of blocked windows and arches, rich in texture and colour, with the buttressed, diminishing staged pile of the tower beyond. Inside a flood of snow-reflected light comes through the gigantic ...

[transcript of sketchbook page illustrated opposite]

In early 1940 Piper's life and career were in a state of both hope and despair. Air raids were expected, and while his own family lived in the country and seemed safe, the prospect for friends in London was grim. His major art projects – notably a new design for an opera at Glyndebourne and an exhibition at Leeds – were cancelled or postponed, and his Shropshire guide for Shell could not be published. Yet his exhibition had suddenly sold out. Piper had had a few patrons before the war, such as Michael Sadler, but now he became admired by powerful members of the intellectual establishment, including Kenneth Clark, Colin Anderson,

37.
pages from *Sketchbook*
1940–41

Kirby Hall. Evelyn says "very well … built
a la moderne .. but the avenue ungraceful and
the Site naked." Beautifully naked it remains,
a yellow, half-ruined palace in a bare world
landscape. Plan preserved in the Soane
museum and John Thorpe, the architect,
marked on it "first stone laid 1570". Office of
Works took it over 1930, but has not ruined
it. Some repairing work going on, not too
much mowing and rolling. The garden house
& gates, with heavy mouldings are
very effective.

Fotheringhay.
The church is like a fragment of a cathedral,
chancel destroyed:
The enormous nave remains, pinnacled aisles
with slender flying buttresses. The East end, outside,
is as good as any decayed English facade:
an area of blocked windows and arches, rich in
texture and colour with the buttressed, diminishing octagonal
pile of the tower beyond. Inside, a flood of
snow-reflected light comes through the gigantic

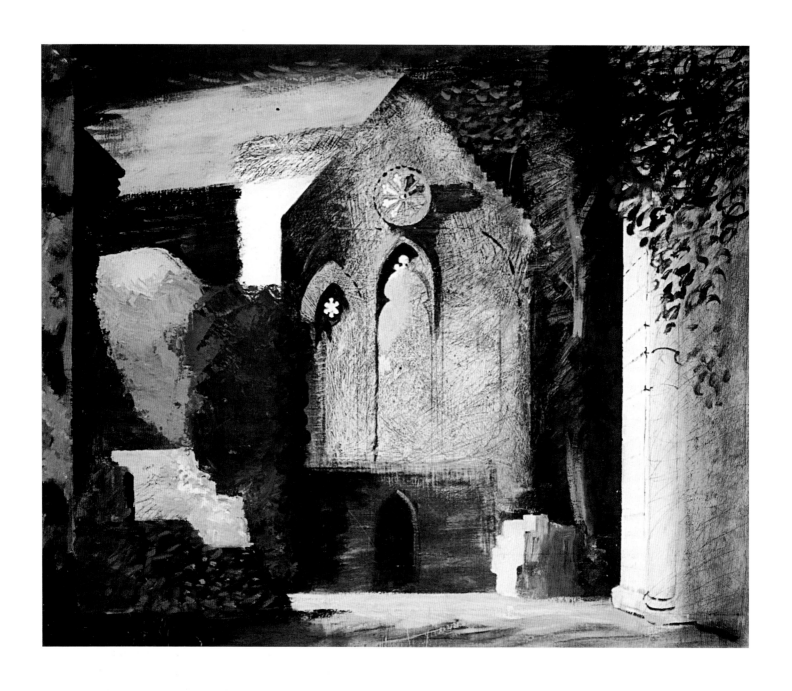

39.
Valle Crucis Abbey
1940

Osbert Sitwell and Charlotte Bonham-Carter. It was these kinds of people who became cultural leaders in the 1940s, while the more professional directors of the avant-garde such as Herbert Read, had to make space on their platforms. This was in part because there was no longer the opportunity to be the first first to rush from Paris with the latest news, and also because the momentum was with those who were encouraged by the demonstrably British, rather than foreign.

Experimentation in the arts seemed inappropriate at a time when people were coming together both emotionally and in matters of taste, rather than being divided. The shift in taste was not just a matter of looking to patrons in the established upper classes, since the leading intellectual publication in Britain, which was keen (against the trend) to preserve contact with France, was close to the Pipers, both in attitude and personally through its contributors. In November 1939 Piper had been asked to design the first cover of this new literary monthly, which was to be called *Horizon*. The intention was to maintain critical standards during the war years. The contributors in the first issue convey the tone of this new world: W. H. Auden, H. E. Bates, John Betjeman, Cyril Connolly, Walter de la Mare, Louis MacNeice, J. B. Priestley, Frederic Prokosch, Herbert Read, Geoffrey Grigson, Stephen Spender and Henry Moore.

The first appeal to Piper from the new Ministry of Information came in April 1940, when he was invited to work for the WAAC. Two days later Leigh Ashton, the former Director of the Victoria and Albert Museum, wrote to him from the Ministry, asking for 'a series of pictures of Air Raid Precaution control rooms'. There was to be a fee of up to 100 guineas, his expenses would be paid and all his sketches would have to be submitted for censorship.

Piper did two of the paintings within the next few weeks, having gone to Bristol in great secrecy to see the ARP headquarters. The control rooms were, naturally, underground. The pictures he made were virtually the only interiors he ever painted, apart from those of churches, and were a blend of abstraction, observation, patriotism and high security, pushing him into one of the few attempts outside revolutionary Russia to be avant-garde and representational at the same time. The rooms were in reality modernist spaces, and did not require transformation to be seen as such, so there is a disjunction in his pictures between the real perspectives of corridors and tables and the artificial arrangement of stencils and illumination.

The two paintings have been omitted from books on Piper, perhaps because they are untypical, yet they connect the modern style with the bureaucracy of aggression. They are also among the few buildings less than a hundred years old that Piper ever painted (towards the end of his life he returned to a similar design when he was unexpectedly and unavoidably commissioned to paint an oil refinery). The Control Room paintings were displayed at the National Gallery in July 1940 in an exhibition of British War Artists. Piper disliked this commission and asked Clark if he could do something else, but it took until August to get his file transferred to the Ministry of Transport for commissions based on 'pictures of war activities'.

In the midst of this period of the Phoney War, life returned to relative normality. Piper took part in a group exhibition at the Lefevre Gallery and, surprisingly, was able to go again to Wales in July, choosing to stay at a pub in Dolhyfryd, near Denbigh in the Vale of Clwyd. This choice was suggested by an old grangerised guidebook he owned, which had added illustrations, and he took this with him as well as a postcard reproduction of a drawing by Thomas Girtin to compare to the landscape. He sketched Valle Crucis Abbey, and, in his painting of it in 1940, he repeated at the right of the picture a buttress similar to the one he had painted in the Control Room corridor.

4. THE BLITZ AND THE BAEDEKER RAIDS 1940–43

Piper was painting historic ruins before any bombs fell on Britain. During the first years of the war he deliberately sought out and sketched many of the well-known monuments of English architecture, especially those that had already appealed to the picturesque aesthetic of the late eighteenth century. This work was a meeting of three different ages: the historic architecture, whether medieval or later; the style of Cotman and Gilpin, and their contemporary watercolour painters; and the painterly habits of Piper himself in the 1940s. He made then some of his best work. He went to ruined abbeys, such as Valle Crucis, Rievaulx, Lacock, Mulcheney and Llanthony, and to the great country houses of Seaton Delaval, Holkham, Castle Howard, West Wycombe, Stowe and Fonthill.

These paintings of 1940–42 were indeed one of the moments of reconstruction in British art, which Piper had believed necessary from before the war. The buildings were not (in any normal sense) places where people lived or used for worship, and if they were not prodigiously ruined in reality, they certainly looked as if they were in his pictures. They appear as an inheritance, still valuable if now impotent. His own use and development of this inheritance was that of a modern European artist. The abstract sources of his style were both French and British, but it was his own vision that transformed his subjects, reconstructing them from ruins.

There were still occasional requests from Recording Britain, which Piper felt obliged to fulfil despite the token payment, and in November 1940 he and Myfanwy were staying in Northampton while he painted the church at Newport Pagnell. The WAAC, which meant in effect its Chairman, Kenneth Clark, had a different interest from Piper, and he had asked him to record bombed churches. The Blitz had at last begun in August, with London the chief target and the effects on its buildings were disastrous. About thirty of the London churches had soon been destroyed, along with large areas of the East End. Piper had to leave his address with the officials, and on the morning of 15 November, Clark sent him a message to say that most of the city of Coventry, including the cathedral, had been set on fire by a raid the previous night. Permission was hastily arranged for Piper to go there immediately in order to make sketches. The raid on Coventry was the first on such a scale. More than four hundred bombers attacked the city centre over a single long winter's night. Coventry was an industrial city, with many factories that had been converted to making armaments. But such a large number of planes could not single out particular targets, and the city centre – an historic old town with a mix of old and new buildings built on a medieval plan – was largely destroyed. When Piper arrived there were still fires burning, with attending fire engines and ARP officials recovering bodies. He remembered an extraordinary smell, whether from the explosives or from what was burning.

Despite having a job to do, Piper felt like an intruder at a private disaster, and did not like to be seen to be drawing at such a time. He went to the cathedral as asked, and to St Mary's Hall, but to none of the private tragedies or to the destruction of houses and factories. At first he could not imagine how to cope with it, but he saw some houses next to the cathedral which were undamaged, and one had the brass plate of a solicitor's office. Piper described it as a sight familiar from his youth as a trainee lawyer:

> It was a port in a storm. I went up and there was a girl
> tapping away at a typewriter, in a seat by an upper window,

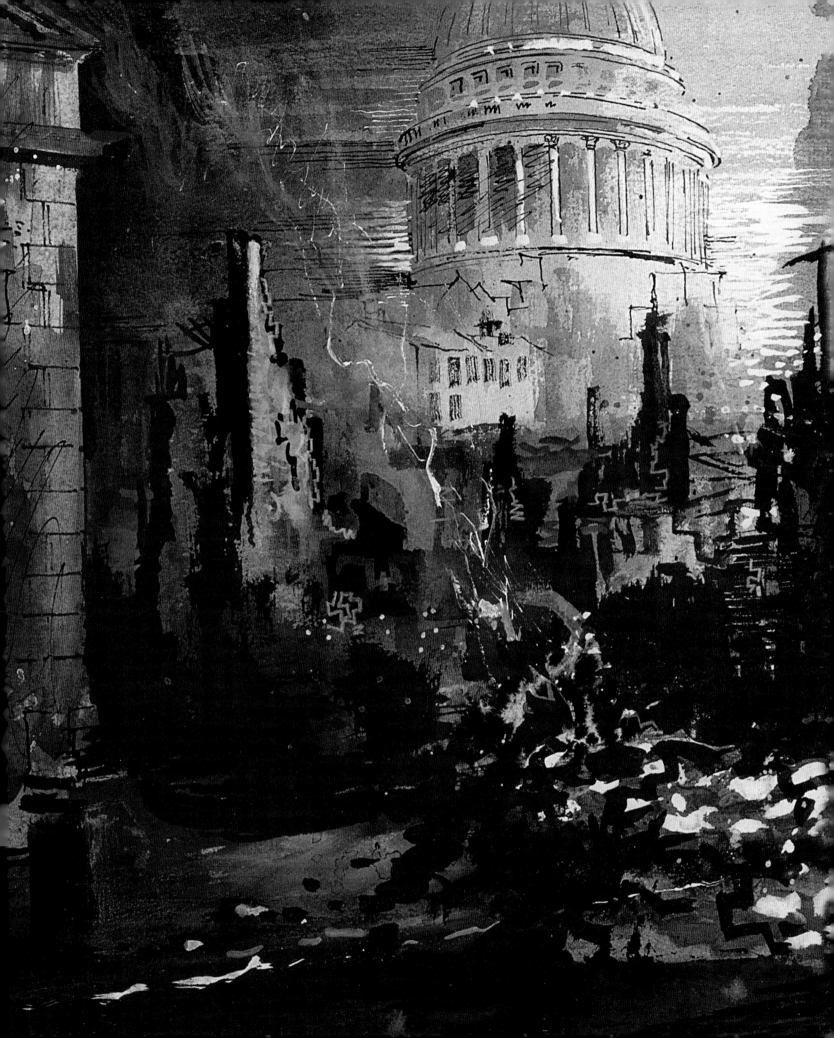

St John's
Waterloo Road, London
Photograph by John Piper
1940–41

as if nothing had happened. I said 'Good morning. It's a beastly time isn't it?' And she explained that she had only just come on duty. I told her I had been ordered to do some drawings. She said 'Of course, you can have my place.' She moved her typewriter to the other side of the room and I started drawing the Cathedral.[13]

The office was opposite what had been the east window of the cathedral, above the level of the lower chapels, and Piper drew the apse, which was now no more than a screen with scorched tracery. He then went down inside the cathedral, where he sketched and photographed a view from inside the nave looking east, with what had become a box of walls on three sides of him, the whole suddenly exposed to the sky.

There was an immediate need to present this disaster in a more positive light, to think of it not in terms of the loss of life and the cost to the industry but in terms of moral defiance in the face of an attack on a civilian city centre. Even the word 'cathedral' used in the role of a victim was eloquent. Piper finished two paintings, one of which was quickly used by the Ministry of Information in the form of a postcard that was published by the end of November. His view of the cathedral was similar to his paintings of Rievaulx Abbey made the previous August, with open, ruined windows and a box-like construction with no roof. In his painting of Coventry Cathedral's exterior the tracery is outlined sharply against white, with an unnaturalistic grey-blue light inside the hollow building. The architecture occupies one simplified scheme, and the colouring another, with a complicated pattern of ruled edges at the centre of the painting, where the canvas was cut away with a razor to expose the board beneath, which allowed a different working of texture.

For a time, this small painting became for Britain what Picasso's *Guernica* had been for Spain, and a symbol of national resistance to Hitler. It was not at all accurate in detail – the tracery was not broken at the centre – and the picture depicts the building still burning at night. The strong colour is heraldic,

like a flag, and the white light radiating from over the altar suggests a spiritual presence. Sixteen years later Piper was commissioned to design stained glass for a huge bay window in Basil Spence's new Coventry Cathedral. Again, Piper took as his motif for the design a white light radiating from the centre. This triumphant design remains an extraordinary echo from one of the lowest points of the war.

Piper followed the Blitz to two cities, Bristol and London. The House of Commons was bombed in May 1941, and he went there quickly to sketch, making several paintings. The records of the WAAC note such matters as his expenses and his submitting work to the committee, but do not record any consultation about what he should be asked to paint. Such decisions were probably made in telephone calls to Clark. Piper's pictures at this time are all abstracted, with a simple shape and vivid primary colours against a structure of browns and black. The colours suggest an analogy to bleeding wounds. There are two drawings of the bombed Christ Church, Newgate Street in London, in a sketchbook of 1941, which he made standing on the spot. The outlines are scribbled quickly, in caricature, and the general colours are written in words over large areas – 'Blackened', 'Pinkish-red infillings', 'Darker' and 'Naples' – as if an overall impression of the colour of certain areas was all that he sought.

The artist most akin to Piper was Graham Sutherland, who was also working for the WAAC but on a salaried basis. His pictures of devastation in the cities were closer to Surrealism in style, and he made much of the sinister shapes of twisted lift shafts in ruined factories. In May 1941, Sutherland began to paint in the East End of London, and his drawings came to look more like Piper's. They shared a similar range of colours, although Sutherland more often used a green-yellow contrast. Sutherland requested permission to photograph, since he felt threatened by the people living in, or who had been living in, the houses he was drawing. Piper would have been as much a stranger to the East End as Sutherland, but he did not paint streets of houses and

so did not share the same dilemma. There is a feeling of intrusion into privacy in Sutherland's paintings, which Piper avoided by keeping to buildings already idealistic in type. Neither of these war artists was intending to speak for the working class victims of the Blitz.

It was sometimes felt at the time that the ruined buildings all over the country presented some new kind of attraction, and that the destruction of the slums in London and elsewhere would in the end be beneficial. Piper wrote of Norwich towards the end of the war that the bombing had made it look better, and more like a drawing by Cotman, and anyway 'better a war-veteran than a museum-piece'.[14] Stephen Spender's poem *Epilogue to a Human Drama* is close to Piper's paintings of the Blitz, with his vision of 'Blood and fire streaming from the stones'. He also saw it from a distance, as if watching a play:

> The City burned with unsentimental dignity
> Of resigned wisdom: those stores and churches
> Which had glittered emptily in gold and silk,
> Stood near the crowning dome of the cathedral
> Like courtiers round the Royal Martyr.
> August shadows of night
> And bursting days of concentrated light
> Dropped from the skies to paint a final scene –
> Illuminated agony of frowning stone.
> Who can wonder then that every word
> In burning London seemed out of a play?[15]

This lordly appreciation is more extreme than Piper's but, nevertheless, in both cases it appears callous to have so ignored individual suffering. The lot of the individual was not the concern of the Ministry of Information, of course, and this social distance is common even to Bill Brandt's photographs of underground stations full of people sleeping. It was a distance that was the core of the class structure of the 1940s. In this sense, Piper's paintings are an exception. The success of his oil paintings of the Blitz, despite their modest size and their emptiness, lies in the extent to which the buildings stand not just for patriotic ideals

but also, by inference, for the physical pain of inflicted wounds. His abstraction had remained close to an ordinary and universal perception of the body.

An unexpected commission revived Piper's interests in the English watercolour tradition. Jasper Ridley, a long-time friend of Queen Elizabeth, together with Kenneth Clark, who among his other posts was also Surveyor of the Royal Collection, arranged for Piper to make watercolour views of Windsor Castle. The intention was to leave a personal record in case the castle were ever destroyed, which seemed more than possible as bombs had already fallen nearby. While this proposal was still supposed to be a secret, Kenneth Clark's wife Jane, who was now a friend of the Pipers, warned the Pipers of it, but they had in any case guessed that there was some reason for their being invited to stay at, and paint, Blagdon in Northumberland. This house belonged to a relation of Jasper Ridley, who was asked to check the suitability of the Pipers. Having passed this appraisal, in August 1941 Piper was commissioned to make a group of drawings at Windsor for a fee of £150, which was duly paid the following June.

To ensure that the drawings were not too abstract, Piper was asked to look at the watercolours of Windsor painted by Paul Sandby in the 1760s before he started work. Piper's first group of Windsor drawings, mostly of the interior courtyards, was not unlike Sandby's careful record, but he replaced their charm with an unearthly lighting and an alarming absence of people. Six of the drawings were given a prime place in the National Gallery's second exhibition based on the *Recording Britain* project in July 1942. The success of these drawings led to a second commission, in which he felt less constrained in style. In the summer of 1942 he worked from the roof of Windsor Castle for a few weeks, writing to Betjeman:

> I have been having a very nice time on the roof at Windsor. Society up there much nicer: housemaids cleaning tennis shoes with Blanco. Several good rows about art with O. Morshead [the Librarian] lately, but he is lending me the transcript of the Farington Diary to bring home vol. by vol.:

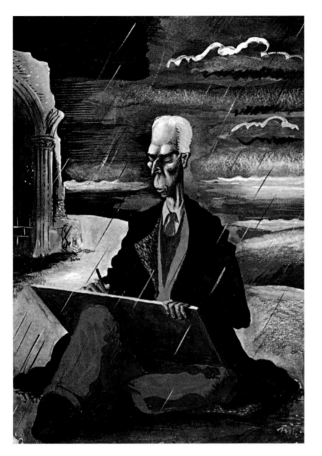

very good for train reading, and makes one look as if one's
working for M.I.32B.[16]

He worked there again the next summer, when there
were spectacular thunderstorms: 'I have been enjoying
some wonderful thunderclouds piled behind Windsor
Castle ... Dark grey scudders rising against pale dove
colour, and pinks and dingy purples'.[17] It was after he
had shown these watercolours to George VI, in the
company of the Deputy Surveyor, Benedict Nicolson,
that both Nicolson and Piper passed on the King's
remarks 'you seem to have very bad luck with your
weather, Mr Piper'.[18] The King was not, however
charmingly, mistaken in reading the watercolours liter-
ally (since he no doubt also remembered the storms),
though he had not thought that these conditions were
precisely what Piper had needed. It is difficult to know

whether the King was intentionally being funny, since
he also joked, when he saw a blank sheet of card, that
there must have been a snowstorm.[19] Osbert Lancaster,
a friend and neighbour of the Pipers, showed both sides
of the story in his cartoon captioned 'Mr John Piper
enjoying his usual luck with the weather.' The drawing
is of the artist sitting lugubriously in the pouring rain
with a sketchpad on his knees.

There was a renewed phase of bombing of Britain
in 1942 aimed at historic towns such as Exeter, Bath,
Norwich, York and Canterbury, which had supposedly
been chosen from the well-known series of German
guidebooks published by Baedeker. In April, the city
of Bath was bombed in one of these 'Baedeker raids'.
Piper was send there by the WAAC, this time with the
commission to paint, in watercolour rather than in oil,
a record of the destruction of the historic buildings.
The bombing was scattered, and Piper chose to paint
the transformation of partially burnt to totally destroyed
sections along the lengthy facades of Bath's Georgian
terraces, in some cases with a wide scale to make this
point. He found it a hateful task:

> I went to Bath to paint bomb damage. I never was sent to
> do anything so sad before. I was miserable there indeed to
> see that haunt of ancient water-drinkers besmirched with
> dust and blast. 3 houses burnt out in Royal Cresc, bomb in
> middle of Circus, and 2 burnt out there; Lansdown chapel
> direct hit, 10 bombs in front of Lansdown Cresc. Somerset
> Place almost completely burnt out: a shell ... 326 killed,
> 1800 houses uninhabitable ... My God I did hate that week;
> made possible by Clifford and Rosemary Ellis who took
> me in in spite of 14 students evacuated from their destroyed
> art-school.[20]

Piper had already planned to publish a King Penguin
book of the Windsor drawings, with text by John
Summerson, at the suggestion of the editor Nikolaus
Pevsner, who was an admirer of Piper's work. Nothing
came of this, but Piper then planned a booklet of his
Bath watercolours, intended for one of the popular
wartime series about the defence of Britain, but again
this was not published.

War art was also used for propaganda abroad, and in June 1942 the British Information Service organised an exhibition at the Museum of Modern Art in New York, which included the two Coventry paintings. The Control Room paintings had been included in a similar exhibition in New York the year before, but in 1942 it was the first time that his work of this kind had been seen in America, and was the start of some appreciation there. The New York dealer Curt Valentin, who had

friends in common with the Pipers, including Alexander Calder, put together an exhibition of British water-colours by Graham Sutherland, David Jones, Henry Moore, Paul Nash, John Tunnard, William Roberts, Ceri Richards and Piper during 1944. He later gave Piper his first one-man show in America.

The same retrospective melancholy that is the mood of the Bath and Windsor paintings is evident in Piper's views of Renishaw Hall in Derbyshire, commissioned by the man he referred to even in later life as 'my patron', Sir Osbert Sitwell. Sitwell spent the war writing a five-volume history of himself, his family and particularly of his father Sir George, and wanted some views of his house as illustrations. Piper is not mentioned in the books and, although he stayed at Renishaw and later travelled to Italy with Sitwell, he was always an employee rather than an equal. Evelyn Waugh, who

was staying during Piper's first visit, implied as much in a letter to a friend: 'There is an extremely charming artist called Piper staying here and making a series of drawings of the house.'[21] Edith Sitwell, an unlikely mother figure, was sympathetic, and insisted on knitting him several immense pullovers in thick wool, using up some of his clothing coupons. But all of her efforts turned out to be far too large, according to Myfanwy, and were never worn.

There are more than fifty paintings and drawings by Piper of Renishaw and the buildings nearby, which followed the first commission in May 1942. The work was a vital financial support for him during the war. The daily conversation at Renishaw must have given an idiosyncratic view of modern history, if it resembled Sitwell's published writing of this time, and he had given up reviewing modern art, with the exception of the work of Tchelitchew and Piper. Seen together, the drawings – most of which are winter scenes with bare trees against the pink and ochre lighting on brick and stone – seem to form a massive single work in many parts. They build a single portrait of a remarkable building and its surrounding gardens and woods, all totally empty, and a mixture of profusion and desolation. As Sitwell sat at his desk writing his autobiography, he was surrounded by Piper's paintings, arranged three deep around the walls of his study. The series is a tribute to both writer and artist, and a view of the house as a memory of the past.

In the war-damaged towns of Britain, the Government ran a number of subsidised 'British Restaurants' for the many people who had been bombed out of their houses or were on the move from place to place. As an offshoot of the WAAC, Jane Clark, to the despair of Piper and others who found her enthusiasm excessive, set about asking artists to decorate these British restaurants. Many of the interiors were cheered up with painted murals, reviving a trend in British art that had been promoted by pupils of the Royal College of Art from the 1920s, but had since suffered from lack of patronage. Piper's plan for the restaurant at Merton

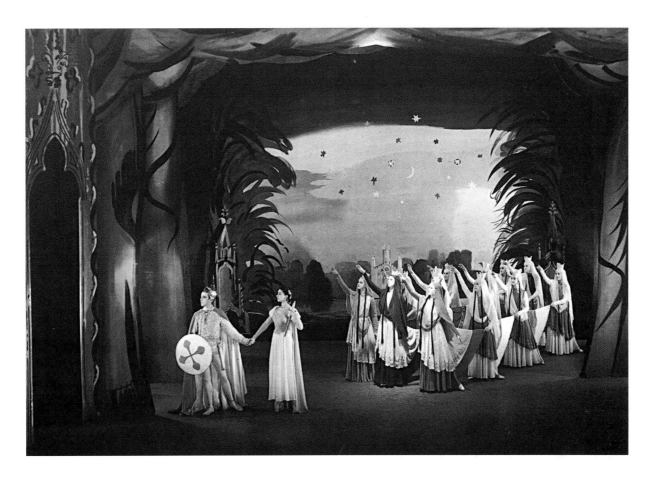

Priory in south-west London ignored the usual linear and decorative style of mural painting. Instead, he made gouaches of his favoured subject, ruined buildings, and passed them on to scene painters to enlarge. Oleg Polunin at the Slade School of Art enlisted some of his pupils, including Mary Fedden, to paint them onto canvases on the walls. Photographs of the decorations were taken for an article in the *Architectural Review*. It is difficult to believe that the clientele were made to feel less depressed by these huge backdrops of moonlit architecture, and there appears now to be a gulf between the sentiments of the diners and the sentiment of the art. The pictures were not murals, in fact, but simply large paintings, and look out of place in a suburban hall on this scale, a lesson that Piper had understood by the time he began to work on murals for the Festival of Britain in 1951.

Even when it depicted a specific place, Piper's art was always addressed to the imagination. However, he was obliged to work in a different way when commissioned by Sadler's Wells Ballet in early 1943 to make sets and costumes for a short propaganda ballet, which was to be called *The Quest*. This was an assembly of talent, but was forced and rushed, and is remarkable now mainly for some of Piper's sets (for which he was paid £50 in total), and for the revelation of a certain kind of patriotism. Choreography and dancing had been renewed in Britain before the war, and it was already the practice of Sadler's Wells Ballet to use artists such as Sutherland and Leslie Hurry, and later Edward Burra and Michael Ayrton, to make set designs. For any ballet, the design was, in effect, a backdrop and front curtain enclosing an empty space. Frederick Ashton was given leave from the RAF to choreograph *The Quest*, which was based on

an episode in Edmund Spenser's *Faerie Queene*. William Walton hurriedly wrote a score, only finishing it a week before the opening night, which he was coincidentally writing at the same time as his music for Laurence Olivier's film of *Henry V*. Robert Helpmann, Margot Fonteyn, Moira Shearer and Beryl Grey were to dance. In the general spirit of survival by national revival, Piper looked for inspiration to Inigo Jones's theatre designs, which had been republished by the Walpole Society in 1924 (a copy of this book was at Renishaw). Piper adapted them with Gothic additions and had to add the colour. The episode chosen for the ballet was the quest of St George to find Truth, and required fantastic scenery, with castles and places of magic, holiness, good and evil. The backdrop for the last scene, of a lake at sunset, was adapted from a set by Jones for Sir William D'Avenant's *Britannia Triumphans* of 1638, with the addition of some pavilions that looked like enlarged fifteenth-century font covers. This backdrop was recreated at half full size for a room in Piper's exhibition at the Tate Gallery in 1983. With the correct illumination, it was again enchanting in its own right, beyond any wartime need to encourage hope and sustain morale by means of historical flattery.

The WAAC gave Piper successive short commissions, while he was liable for conscription at any moment. He was a member of the Home Guard at Henley at all times, and kept a rifle in his house. The Pipers now had a second child, Clarissa, and children's books came regularly in the post from Joe Ackerley at *The Listener* as review copies for Myfanwy ('they're awfully easy to do: smelling them is almost enough', she said).[22] Myfanwy's Aunt Lena often stayed, and they employed an Irish maid. The house was used as storage for people and things, and several friends left children with the Pipers to look after. Through Piper's various friendships, the libraries of the Society of Antiquaries and of the Curwen Press, and the records of the Group Theatre, were housed in the farm buildings at Fawley Bottom. Also stored there at times were Mervyn Horder's grand piano, which allowed Piper and a musical guest to play

duets, as well as the business records of Robert Wellington's *Contemporary Lithographs*, and his car. They kept pigs in one of the outhouses – as did everyone who could do so, in the interests of food supply – and Myfanwy went along to the meetings of Lady Brummer's Pig Club at Gray's Court in Henley. As a war artist Piper was required to give lectures and radio broadcasts. He also put on two exhibitions for the Council for the Encouragement of Music and Art, one of modern art for the church (which highlighted the architect Ninian Comper) and another of modern designs for the theatre.

The last two years of the war did not provide commissions that stimulated Piper's interest. There were complaints within the WAAC in 1944 that Monnington, Sutherland and Piper in particular were not producing enough work to justify their deferral from military service, the reason being that there were not enough commissions to go round. Piper was transferred again in the summer of 1944 from the Ministry of Agriculture (which had asked him to paint a fossilised bog oak found in land that was being ploughed for the first time) to War Transport, and he was given full time employment for several months. He was sent to paint the ports at Cardiff, Avonmouth, Poole, the West Country, Southampton and Dover. There was an unrealised plan to send him to Brest in France which, as he wrote at the time, 'I may get out of by pretending I want to go very badly.'[23] Hence his last work for the WAAC was pictures of railway sidings and views of ships in harbours. He may have asked for these subjects, thinking of his pre-war interest in the south coast, but his constant concern with images of decay found no relevance in trains and ships. These drawings were not as good as his paintings of Renishaw and Yorkshire, and his new interest was in painting the landscape of Snowdonia.

First sketch for 'The Quest' (Sadlers Wells Ballet) John Piper

52.
Sketch for 'The Quest'
1943

50.
Sketch for 'The Quest'
1943

5. NEO-ROMANTICISM

In suggesting that the artists Frances Hodgkins, Graham Sutherland, and Ivon Hitchens, with Henry Moore, were a distinct group, and in calling them for the first time 'Neo-romantic', the critic Raymond Mortimer was responding to an evident similarity of style. It was such an appropriate term that it is surprising that the name did not catch on for some years. His proposal came in a review of an exhibition at the London Museum of New Movements in Art in March 1942,[24] the title of which rather implied that the new movements should have names. Mortimer divided the artists into three, with the Neo-romantics being the remainder after taking away the recognised Abstractionists and Surrealists – not difficult as the display had already installed the artists in three separate rooms in this way. Mortimer was a champion of Sutherland, and gathered this new party around him, but did not mention Piper at all, although he had work on display in the exhibition. The Neo-romantics were a step beyond the other two categories, since Piper's progression through abstraction was matched by Sutherland's through Surrealism and by Moore's negotiation of his own path around both of these modernist styles. Moore, Piper and Sutherland had shown together in London the previous month, when a group exhibition had moved on from its opening at Temple Newsam House near Leeds in July 1941, in a tour arranged by CEMA.

It was especially this show at Temple Newsam that linked these three artists together, and came to define what was meant by Neo-romanticism. This was not a chance grouping, and had originally been planned by Philip Hendy, the Director of Leeds City Art Gallery, for 1938, as part of his series of exemplary shows of modern art. Neo-romanticism was a term that was already in use for several literary movements, but

Mortimer may have borrowed it from a group of French and Russian painters active in Paris between the wars and later in New York. This group was formed around Christian Berard and included Pavel Tchelitchew.[25] However, despite the fact that these French Neo-romantics were well known in London, particularly to the Sitwells, they were never of much interest to Piper.

Mortimer's use of this new label remained at the time no more than his own suggestion, and was only taken up seriously a few years later, effectively in retrospect, with Robin Ironside's study of the period, *Painting Since 1939*,[26] written in 1945 and published at first obscurely but then more widely in 1948.[27] This re-launched the idea of Neo-romanticism just in time for it to be attacked by advocates of the post-war reinvigoration of painting and of the return of internationalism as an ideal. Thus there was no explanation at the time of what the style was supposed to represent, and its first currency was as an expression of isolation, as with Ironside's appraisal, or, increasingly, of disapproval.

Neo-romanticism was a term that Piper never used nor accepted, in part because of his personal dislike for Mortimer but also, and rather more significantly, because he hated the restriction of labels. He did, however, often imply that he would be happy to be thought part of a continuing Romantic tradition of British art. In today's historical account, the Neo-romantic group is conventionally thought to consist of three generations: Paul Nash, the eldest, in honour of his landscapes with emotional symbols; Moore, Sutherland, Piper and Hodgkins as the central figures; and their younger admirers and pupils of the mid 1940s, such as Keith Vaughan, John Craxton, John Minton, Michael Ayrton and Leslie Hurry. Such classification allows for varying, and often quite vague, levels of participation within the group. Piper was probably

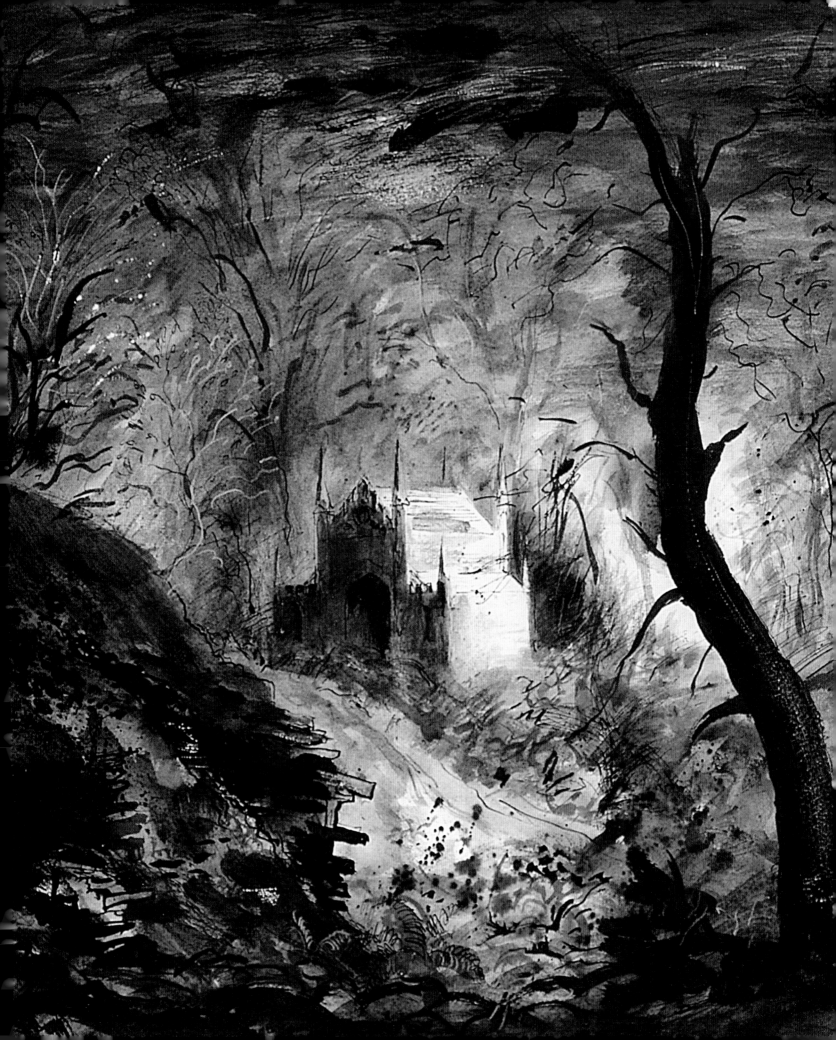

the artist whose work of the 1940s is most fairly covered by what this style has come to mean.

Piper's own term for the art of Nash, Hodgkins and Sutherland was 'contemporary romantic painting', meaning much the same thing but without being elevated to an -ism. He used this description in his own booklet, one amongst a flurry of publications at the time which placed the summit and characteristic achievement of British art not in the Grand Manner nor in the ambitions of modern art, but in the visionary art of William Blake and Samuel Palmer. Piper had been asked in June 1941 to write a study of British art for a series of publications called *Britain in Pictures*. This was

a vast array of booklets, clearly of benign nationalist interest (and possibly modelled on the German Blue Books series), all with either the word 'Britain' or 'English' in the title, except for a few where national identity was implicit, such as those on *Public Schools* and *Women's Institutes*. Piper's booklet was number 34, and was published in November 1942 with the title *British Romantic Artists*. The ideas behind this text he held jointly with Grigson, Clark and Betjeman, and when Piper sent a copy to Grigson and his wife Bertschy, he inscribed it by hand 'to G. and B. with much love and acknowledgements for facts and fancies pinched wholesale'. Grigson's poetry anthology, *The Romantics*, which was published in the same month, was dedicated to Piper. The theme of Piper's book was that British art should be seen as a tradition of visionary landscape, with occasional outbursts of visionary figure painting such as by Fuseli, Blake and the early Pre-Raphaelites, all expressed by means of the 'subjective use of particular details and moods of nature'.[28] Piper admired Palmer so much that he wanted to recreate his own work from Palmer's starting point, and he went to Lullingstone

Park near Shoreham in Kent to draw the same trees that Palmer had drawn in the 1820s. In a shift in his art away from a linearity like Cotman's, Piper was attracted to the thick, mixed-media technique of Palmer's work. This return to a place already seen by another artist is remarkable, and was essential to Piper. While he never discussed it in such terms, it seems to have represented for him a necessary conjunction of past and present at a certain place, as if one artist conferred a blessing on the other.

The 'Palmerish' nature of this new painting was a matter of both subject and technique. Piper had painted ruined cottages from time to time, and thatched cottages had been idolised by Sutherland in his etchings of the 1920s, but in early 1941 Piper began to paint a series of country cottages in a manner that was far more intense. They now had writhing mossy roofs, sometimes falling to the ground, and were often seen by moonlight, painted in the rich brunette colouring of Palmer's gummy watercolours: they were like 'ruined barns with roofs richly clotted with decaying thatch and moss,' as Piper wrote of Palmer.[29] Several of Piper's paintings of ruined cottages were exhibited at Temple Newsam in 1941, and he sought out and painted others over the next few years in the south of England, in West Wales and in Yorkshire. In some pictures the oil paint is worked into corrugated shapes, in flattish areas that contrast against one another. The browns and blues, greys and pinks of these paintings and gouaches are a characteristic of Neo-romanticism, as is the application of colour in the gouaches using a wax resist to leave areas unmixed – a method possibly first used by Henry Moore, and much copied by other artists.

The cottages look melancholy, and many of them bear the expression of a human head. This transference of the human to landscape was fundamental to Neo-romanticism. Herbert Read had already described Moore's carved figures as landscapes in 1931,[30] and in a Third Programme broadcast in 1941 Sutherland, Clark and Moore, at least in the edited version in *The Listener*,[31] talked of this with some deliberation.

Sutherland's position was clear: 'Personally I find that practically all the figurative elements are contained in landscapes. In a sense the landscape painter must look at the landscape as if it were himself – himself as a human being.[32]

In the autumn of 1942 John Betjeman, who was then working in the British Embassy in Dublin, wrote the introduction for a new Penguin Modern Painters booklet on Piper. Clark, the editor of the series, suggested the illustrations, which Piper adjusted by adding some abstract works (all of which Clark had thought to omit), a nude and some of his drawings of churches. The illustrations are Piper's own view of his best work to date, and of the thirty-two plates seven were wartime commissions, including two of the Bath watercolours.

The plates were paired carefully across each double page, and the nude – of Myfanwy reclining voluptuously on her back – is across the page from a landscape of North Wales, apparently of a peculiar elliptical hole in a field, which was in fact the remains of a Roman amphitheatre. This was a further example of what Clark called 'the Pathetic Fallacy',[33] a deliberate relation between body and land, here female body and ancient land. Myfanwy had posed in the long grass behind the studio at Fawley Bottom, and is shown with her legs wide apart and wearing high heeled shoes. If it had been realistically painted the pose might have been pornographic, but instead she is made to look like some rocky outcrop seen by moonlight. The pose of this figure could hardly indicate more clearly the parallel with landscape, and with the landscape-body as a site of generation.

An interest in rock formations attracted Piper to the caves of Yorkshire – Easegill, Weathercote, Yardas, Gatekirk and Gordale Scar, which he visited twice, once with Grigson. Before going he assembled all the literary descriptions and illustrations of the places that he could find, which he later used in an illustrated article.[34] He made Gordale Scar look far smaller than it does in the painting in the Tate Gallery by James Ward, but he was not interested in the panorama, only in the access to the interior of the rock. The painting of Gordale Scar is more sharply contrasted than is the drawing he did on the spot, so that the sequence of light and dark rippled edges recalls the similar construction of his pre-war abstract painting.

To some extent Neo-romanticism became a school of art, and soon deteriorated into a mannerism with some younger painters, but there were two more fruitful links with the next generation. In the same way that Keith Vaughan was devoted to Sutherland as a mentor, so John Craxton admired and learnt from Piper. They met probably in the winter of 1940–41, through Peter Watson, one of the editors of *Horizon*. It was Craxton's first friendship with a modern artist and, in addition to some technical help and the example of professional practice, he remembered that Piper showed him how to look at things. In particular, Piper opened his eyes to the beauty of two of his own favourite subjects, medieval ruins and primitive English sculpture. Craxton went to see Romanesque sculpture for himself in the church at Kilpeck in Herefordshire in the spring of 1942. He was struck that here was a national art that was relevant to modern art: 'I was deeply happy and proud that I was born in a country that made such things'.[35]

Robin Ironside's essay was written while he was an assistant keeper at the Tate Gallery. He was also an artist, and resigned from the Gallery in 1946 to become a painter full time. His provocative appreciation of the imaginative vision of British artists, as well as his mistrust of Roger Fry's theories and of abstract art, were of a piece with his own paintings of intensely wrought fantasies, idiosyncratic but not too distant from Klee and Tchelitchew. Yet Grigson published several articles after the war that revealed his impatience with Sutherland and Piper, particularly as founders of a school of painting. He still admired Piper's work, grudgingly, but criticised it for being English in the limiting sense of reflecting the taste of 'a middle-class Englishman', like himself, something of which he now felt ashamed.

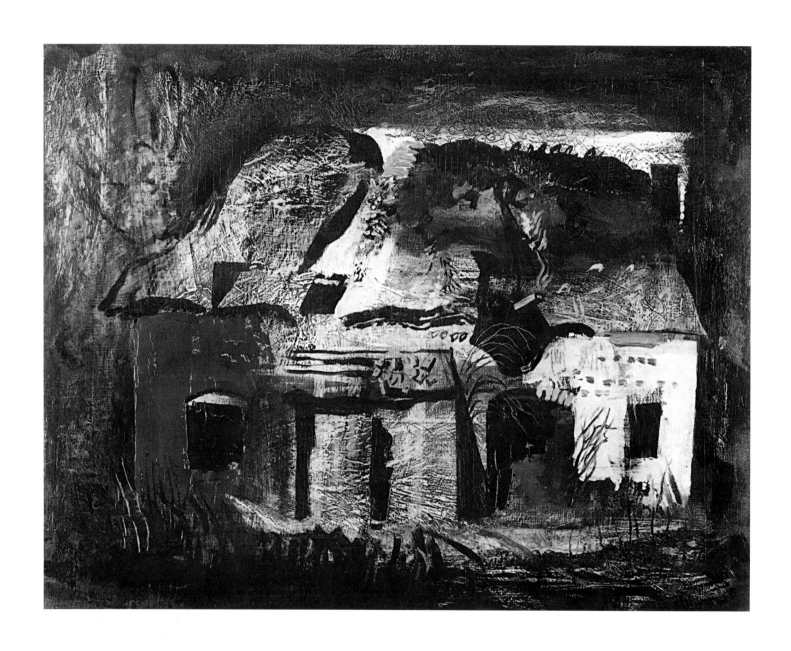

69.
The Cottage by Firth
Wood, Hampshire
1941

44

His criticism of Piper was that his work was national and morbid, as indeed it was. Grigson's title 'Authentic and False in the New Romanticism'[36] broadcast his parting company with the artist whose taste had once been so close to his own. The attitudes implicit in wartime anxiety and nationalism now in their own turn began to seem out of place.

Piper had always wanted to travel, when petrol rationing allowed, to see subjects that matched and extended some visual preoccupation of his own. In North Wales in 1943 he climbed over Cader Idris, probably trying to find the viewpoint of some paintings by Richard Wilson. This led to a major painting of mountains, *The Rise of the Dovey*, and to subsequent periods spent in the mountains of Snowdonia – usually in winter – in order to be able to make large drawings on the spot. He first rented a cottage in Snowdonia, Pentre in the Nant Ffrancon valley, in November 1945, and more or less moved his family into it for the entire winter, decorating and repairing the interior. A winter in such a cottage in the mountains, with no water or electricity, cooking on a primus stove, with a flood of water running through the house whenever it rained, was a bleak proposition. In 1946–47 Piper moved to another cottage, Bodesi, beneath the mountain Tryfan. He was prepared for some discomfort in order to be within cycling distance of the Sublime, a concept he probably thought of quite consciously in the eighteenth-century sense of the word. As one of the Pipers' visitors wrote back to them in a thank-you letter, 'it was *awful* and *horrid* in the proper sense'.[37] *The Rise of the Dovey* repeats the pattern of *Gordale Scar*, but on a larger scale and with a more radiant sense of warm against cold in the colouring. The formal simplicity of the painting implied questions about the colouring and geology of the different mountains of North Wales, which provoked further visits and led on to a group of gouaches and paintings.

Just as Piper's Shell Guide had assembled notes about all the churches in Shropshire, in a similar way he collected and listed his paintings and drawings of Snowdonia. He planned to publish a book of them with his own text, and at one time listed fourteen colour and fifteen black-and-white illustrations. In his notes he described the particular colours of different areas of rock, as seen in various weathers and times of day. Some of the Snowdonia drawings concentrate on rocks, some on the lakes under the cliffs, and some on the peaks. In each case Piper gave a summary of a clear, formal shape, but paid particular attention to colouring and detail. The geological structure of the mountains, and the weathering and erosion of the shapes, mesh with a construction of formal clarity. In a draft paragraph on 'Colour of the Rocks' he wrote of various areas:

> In an early November sunset about 4 o'clock on the Western slopes of Y Garn [and] Foel Goch the isolated rocks in the darkening grass were a rich magenta colour, and the same rocks can look as white as a newly shorn sheep, or pinkish, or greenish. The range of tone in the rocks is from black to white – blackest moss patches them often, and the white lichen common near the Atlantic seaboard too. And their angular cuts and serrations take deep shadows. On top of the Glyders in places, the richest chrome yellow and chrome orange lichens are predominant. In the Llyn Llydaw region toward Glaslyn there are copper-coloured rocks, pink, black white and true macintosh-coloured rocks lying in confusion. In Cwm Glas the glaciated rocks lie in the shape of enormous half-shut fans, and black and deep green moss scrawls widely-drawn patterns over a main whitish-grey design, which is closed and skirted by rich green grass.

One reason for taking these cottages in Wales was to escape from the telephone in order to be able to concentrate on work. At the end of the war Piper was offered an increasing number of commissions, and he also had two dealers selling his work, the Leicester Galleries in London and Curt Valentin in New York. Work for the stage, including two commissions for Benjamin Britten at Glyndebourne, became a major, but not very well paid, undertaking. The sets for *The Rape of Lucretia* were largely designed under the shadow of Tryfan in his Welsh cottage, and the drawings for this opera made up an exhibition at the Leicester Galleries

The great survey of new artists at the start of the decade was *Sixty Paintings for 51*, commissioned by the Arts Council for the Festival of Britain. Piper was among those approached, but was too pre-occupied with murals and designs for the festival itself, and was not able to send in the paintings requested. In the event it was the festival decorations that seemed old fashioned, and the commissioned paintings suggested the future of British art. The two paintings that Piper should have completed, and which showed his own way forward, are now comparatively unknown, *Rowlestone Tympanum with Hanging Lamp* (1951)[38] and *Clymping Beach* (1953).[39]

Piper the artist was a larger figure than Piper the painter. He would reply to questions about the diversity of his work by saying that invariably it was in painting and drawing that he made the discoveries that he put into practice in stage design or stained glass, or whatever else he may be asked to design. During the 1950s his best work was to be for the stage, in sets for both opera and ballet. His designs after William Blake for the ballet of *Job* in 1948 were an example of a large-scale work that was overtly Neo-romantic in the reference to Blake, but also a development of his current painting in Snowdonia. The ballet had been first produced in 1931, but the original sets were lost during the war. Piper's new designs – like *The Quest*, made for Ninette de Valois' Sadler's Wells Ballet – were coloured variations of particular, well-known details from the set of prints by Blake. It is in performance, with the sight of his small gouaches copied as full-size backcloths, that the link to Piper's new paintings becomes clear. Piper had found a method of representing the mountains on small sheets of paper, and when his drawings of Blake's Heaven and Hell – seen as the Beautiful and the Sublime in the forms of sheep grazing under a tree and as a burning mountain lake – are enlarged in the theatre, they again work on a huge scale. The variety of texture and lighting ensures that the simple, make-believe shapes are convincing as well as being, in their stage version, enchanting. The visual effect of the performance depends on several moments when one of the cloths,

in October 1946. He still worked for Osbert Sitwell, who published some of Piper's drawings in his autobiography. Piper made book illustrations, became general editor of the Shell Guides, wrote a guide to the churches of Romney Marsh, and published selected articles. In the years after the war he and Myfanwy had two more children, and the house at Fawley Bottom was enlarged by transforming the barns into studios.

There was considerable consistency in Piper's work in the post-war years up until 1950, so that it is not easy to give an exact date to his drawings in this period. His style did change considerably, however, from the beginning of the 1950s, but by then he was at a disadvantage with the new patrons of public art in the British Council and Arts Council. They took the line that an international kind of art excluded paintings in watercolour, especially British paintings in watercolour.

painted onto gauze, disappears within second as the
lighting changes, to reveal a different backdrop, in
the same way that the sudden appearance of the sun
transforms a mountain landscape.

* * *

The paintings of ruinous country buildings and the
mountains of Snowdonia that Piper made during the
1940s have remained some of his best work. In the
next decade, he became less interested in oil painting,
although he did not give up the medium altogether:
he continued to exhibit at the Leicester Galleries, with
paintings of complex views of church interiors that
demonstrated a change in his use of spatial devices
and in his colour range. He found new patrons and
new audiences by designing for the opera and through
commissions for stained glass windows for churches.
This was partly a matter of continuing to work with
friends, but was also a renewal of earlier interests.

Piper's sets and costume designs for Benjamin
Britten's opera *Billy Budd* in 1951 mark a return to
the colour, and even the kind of construction, of his
1930s abstract painting, as if he sought to renew his
career from that point and go back to his first love for
the Diaghilev ballets. This opera and its libretto after
Melville look back to another British war, but in
a way that was ambiguous about patriotism and the
military. The diversity of Piper's work and its range
between abstraction, landscape, opera design, ecclesias-
tical stained glass and printmaking is more remarkable
for his resilience in finding new patrons than for any
lack of direction. Such variety was not unusual, and
was matched in the work of the artists he admired,
Picasso, Dufy and Calder.

His preoccupation with a sense of history visible
through a created architectural space was appropriate
to the fictional location of Britten's historical operas
and to the mainstream repertoire of Verdi and Bizet.
The stained glass that he designed, sometimes for huge
windows, such as those in Coventry Cathedral and

John Piper, Benjamin Britten, Peter Pears,
Myfanwy Piper, Edward Piper & Clarissa Piper
photograph by Eric Auerbach
Venice, 1954

Eton College Chapel, relates to the existing architecture, and adds either abstract colour or, in narrative scenes, often reinterprets the architectural sculpture of the Romanesque. The abstraction element in his designs was always in the service of a subject and before a dedicated audience. He returned to landscape painting more directly later on, in a style with various associations including the photographic techniques of screen printing, which once more gave him access to a popular audience. His habit throughout his career of handing over his drawings to expert craftsmen links his art quite overtly to a wider market and to the obligations of public commissions. This reflected a popular mood, as his work as a war artist had reflected the flavour of patriotism during the Second World War.

NOTES

1. Sir Osbert Sitwell, Preface to *The Sitwell Country: Derbyshire domains, backgrounds to an autobiography*, The Leicester Galleries, January 1945.
2. John Piper, 'Seaton Delaval', *Orion*, 1945, p.43.
3. *The Painter's Object*, ed. Myfanwy Evans, Howe, 1937.
4. *AXIS 8*, 1937, pp.6–7.
5. *Architectural Review*, January 1938, pp.1–14.
6. Paul Nash, *London Bulletin*, May 1938, p.10.
7. Stephen Spender, *Trial of a Judge*, Faber & Faber, 1938, p.42.
8. John Piper, 'Abstraction on the Beach', *XXième Siecle*, 1 July 1938, p.41.
9. Frank Ward, *The Lakes of Wales*, Frank Jenkins, 1931, pp. 220–21.
10. Peggy Angus, letter to John Piper, 9 September 1948.
11. Geoffrey Grigson, *Places of the Mind*, Routledge & Kegan Paul, 1949, p.101.
12. David Mellor, 'Recording Britain: a history and outline', in *Recording Britain*, David & Charles, 1990, p.19.
13. Peter Fuller, *The Independent Magazine*, 10 December 1988, p.58.
14. 'Topographical letter from Norwich', *Cornhill Magazine*, Jan 1944, vol. 962.
15. Stephen Spender, *The Edge of Being*, Faber & Faber, 1949, p.29.
16. Piper to Betjeman, undated but July 1942, McPherson Library, University of British Columbia, Victoria.
17. Piper to Kenneth Clark, 3 August 1943, Tate Gallery Archive.
18. James Lees-Milne, 'Prophesying Peace', 10 July 1945, Faber & Faber, 1977, pp. 211–12.
19. John Craxton in conversation with author, August 1999.
20. Piper to John Betjeman, 15 May 1942, McPherson Library, University of British Columbia, Victoria.
21. *The Letters of Evelyn Waugh*, ed. Mark Amory, 20 June 1942, Weidenfeld & Nicolson, 1980, p.163.
22. Myfanwy Piper, repeated to the author.
23. Piper to Basil Creighton, October 1944, Tate Gallery Archive.
24. *New Statesman*, 28 March 1942, p.208.
25. James Thrall Soby, *After Picasso*, Edwin Valentine Mitchell, and Dodd, Mead & Co., 1935.
26. 'Anthology of Younger English Painters', *Counterpoint 2*, 1945.
27. Robin Ironside, 'Painting Since 1939', in *Since 1939*, pp.145–84, Phoenix House, 1948.
28. John Piper, *British Romantic Artists*, W. Collins, 1942, p.29.
29. Ibid. p.30.
30. Herbert Read, *The Meaning of Modern Art*, ed. 1972, p.255.
31. *The Listener*, vol. XXVI no. 670, 'Art and Life', part of a discussion between V.S. Pritchett, Graham Sutherland, Sir Kenneth Clark and Henry Moore, 13 November 1941.
32. *Henry Moore on Sculpture*, ed. Philip James, Macdonald, 1966, p.79.
33. Kenneth Clark, *Landscape into Art*, John Murray, 1949, p.142.
34. 'Notes from a Yorkshire Journal', *Geographical Magazine*, December 1942, pp. 364–7.
35. John Craxton, letter to author, 14 June 1991.
36. Geoffery Grigson, *Horizon*, March 1948, p.203.
37. Reginald Ross-Williams to Piper, not dated.
38. Collection of the National Gallery of Canada, Ottawa.
39. Collection of The Red House, Aldeburgh.

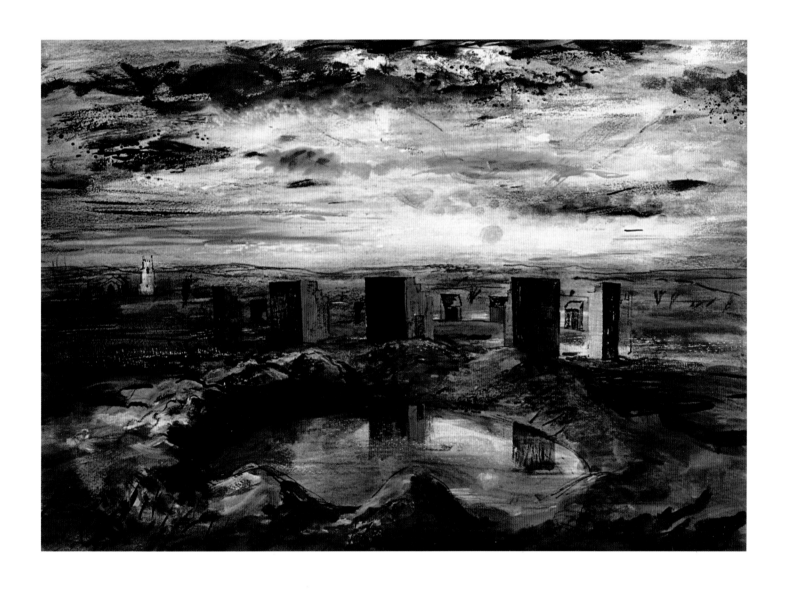

8.
Shelter Experiments,
near Woburn,
Bedfordshire
*c.*1943–44

NEW WAR PICTURES

The latest Official War Art at the National Gallery is the best yet. In the newly-hung room the artists concerned show signs that they are going to create something out of the war instead of merely keeping a tradition alive through it. Some of them are still only changing out of lounge-suits into khaki or RAF blue, but others seem to show that their experience is changing, and that war is something more than an interruption and an irritation. It is not camouflage nor uniforms, nor the clean lines of a gun, nor even heroic profiles, that make good subjects for war-pictures; it is death and destruction, and the agony that stays about the rubbish pile and the grave. Henry Moore's shelter drawings look as if he has been excavating in early tombs: he has dug down and found monumental beauty. His creatures are tragic and sub-merged, but his drawings of them are detached and far more moving than if they were stuck over with labels of sorrow and pity. Paul Nash has made what he calls a 'Dead Sea out of a mass of broken enemy aeroplanes'. This grey amalgam heaving against a moonlit English landscape is frozen into silence and death. Graham Sutherland shows a series of pictures of devastation among City offices, factories and warehouses. If anyone still doubts the wisdom of employing artists who can make records of experience during war he should see these vivid pictures and compare them with what the camera would say about the same subjects; twisted girders pouring over fired rubble-piles; a wall falling like a short man; the broken carcase of a lift-shaft; machinery dangling its severed limbs in the bare well of a mantle-factory.

Stanley Spencer is at work on a large decoration of which he shows here two sections: *Welders and Burners*. The main subject is shipbuilding on the Clyde, but from these sections it is impossible to tell much of the general effect – their shape is awkward and distracting. If we must have war portraits, Barnett Freedman's R.A. *Commanding Officers and a District Gunner* (nineteen of them in one frame) is a good decorative solution.

Ardizzone, Topolski and Kapp – all represented here – are the best illustrators the war has yet made use of. Ardizzone is still character-impressionist, and it is true of him that he has only changed his subjects into khaki. Topolski's first concern is always gesture, though one might call him 'dramatic impressionist', with his big show (just closing at Knoedler's) in mind. If good war-painting is a question of finding new happy effects of colour and form among ruined buildings, and letting the tragedy look after itself, then two water-colours of Aberdeen and Clydebank, by James Miller, are among the best things here. They are pleasing in any case.

At the Leger Galleries, 13 Old Bond Street, there is a new exhibition of war pictures by Clifford Hall, called 'Bombs on Chelsea'. The artist is attached to a Chelsea stretcher-party, and his small, rather slight drawings have a good deal of interest and 'actuality'. They are best when least literary and most formal – as in *Fire Watchers Queuing up for Food and Barrage Balloon, Moonlight*.

The Spectator, 23 May 1941

John Piper at the National Gallery
photograph from *The Tatler and Bystander*,
15 October 1941

Blitz: War Pictures by British Artists
Cover design by John Piper
Oxford University Press 1942

TOWERS IN THE FENS

The best churchyards in the Fens have long grass, bent
in the wind, tangled and brown here and there between
the grey and ochre gravestones, matted round the base
of the church walls. New green grass eddies with the
breeze into the angles of the tower buttresses. These
buttresses have been worn by the weather into shapes
with contours that Cotman was a master at repre-
senting. From a distance their upright outlines are
straight enough, but straight and upright with an
unaccountable richness. Closer, they are seen to have
dissolved away round their stratified core of stone as
if they had been under water or had been sand-blasted
by a vague and artistic mechanic. The serrations in the
surface of each block of stone are as deep as the gaps
made in the joints by the weather, and so the substance
of the wall has become a sculptural whole, its surface
carved by nature with infinite feeling and mastery.
It is incised and pitted by the weather; lichen stars
or spreads it with yellow and gold; the mouldings
of windows and arcades have become encrustations
of curving ribs.

John Sell Cotman set out to etch 'all the ornamented
antiquities in Norfolk' in 1811. Most country churches
were then at an extreme of beauty. Ready to drop like
over-ripe fruit, they were in an exquisite state of decay.
In almost every village church a derelict wicket gave
onto a porch strewn with straw, and a creaking door
led into a nave full of worn grey box pews. The walls
were patched with new plaster in places; in other places
scored stonework was visible where the old plaster
had fallen away and had not been renewed. Clear glass
windows let in the sunlight that streamed over the
faded umbers, ochres and greys of the walls, furniture
and floor, and the whole scene was enriched by the
splash of brilliant red of the tattered hangings on the
high pulpit. There was, too, the jewelled colour of
fragmentary glass in the tracery lights. Cotman saw that
a church in such a place could be a perfect setting for
precise mediaeval mouldings, just as he had already

seen a tangled garden as the perfect setting for the precise proportions of a classical urn on a pedestal. When drawing a Norman door he never omitted the straw or the cracking plaster that neighboured it. Such a church was at least half the product of nature. Half-ruinous, it had indeed become almost one with nature – and Cotman was a specialist in ruins. There were hundreds of these knots of interest among the hills and marshes of Norfolk, and with immense enthusiasm he set out to draw all of them. Dawson Turner, the Yarmouth banker and archaeologist, encouraged him and products of the labour occupy two large volumes of etchings: *Specimens of Architectural Remains, chiefly in Norfolk*. Other products were the beautiful drawings in pen, monochrome or colour that Cotman did on the spot, and from which the etchings were afterwards worked during long evenings in the studio at Yarmouth's suburb of Southtown.

These drawings dwell on three facts: the beauty of texture of decaying stonework and woodwork; the clear light of East Anglia, and (in the exterior view) the wholeness, the oneness – like a good piece of sculpture – of each church in relation to its landscape. The archaeologist and the topographical draughtsman had not been struck by this last point. Cotman was: and his drawings are still alive and real in consequence.

A train journey through the flats of Lincolnshire seems to tell you of a remarkable family of church towers, all related – as closely for instance as the towers of Somerset. In this abnormal country any tall pile looks rather like any other – more like than it is. But there is another reason for the look of family likeness. The builders of the Fen towers realized from the first that here was an opportunity of producing pure architecture, architecture at one of the poles of the art – the sculptural pole, removed as far as possible from the pictorial pole. The vast waste of the Fens would be an unpromising setting for a Fonthill Abbey or a half-timbered gate lodge; but as a setting for the architecture of giant sculpture there are few places like it. So it is fanciful but suggestive to imagine that these towers have been carved out of the level Fens, and the whole area of the land round them reduced in height by a hundred feet or so, leaving them solid and whole, like some Indian rock temples. In the distance from the train or the road, the towers look like solid bodies from which a mould has been removed, leaving them isolated on a vast green dish.

Seen from anywhere within twenty miles of it Boston Stump soars out of the level plain to form a distinguished bulk on the skyline. Far more distinguished in mass than in detail, it shows the mediaeval builders using majestically the Fens as a plinth – the best plinth for sculptural architecture in the whole country.

Wisbech, in Cambridgeshire, is a good place from which to explore the giant sculpture of the Fens. The north-west Norfolk collection is out towards the Wash, between here and King's Lynn. Near at hand are Walsoken (with high-class-wedding-cake arcading) and West Walton, where the same builders must have had a hand, though here they built the tower away from the church, and pierced each side of it at ground level with a wide arch. Long grass still washes up to its base in the wind as it did when Cotman drew it in 1813. Further on is Walpole St. Peter, which has preserved as many mediaeval beauties as any church in England, and near it are the Wiggenhalls, the Tilneys and the Terringtons. Cotman's etching of Terrington St. Clement shows the elaborate sculpture of the church building up in recession from the porch to its final climax, the tower. West of Wisbech across the flats is Crowland, with its much-sketched ruin, north-west is Spalding, and north are the towers of Sutton Marsh – Long Sutton, with its lead spire and, near it, Gedney and Fleet. (There ought to be a guide book story suggesting that these towers are brother and sister: 'Gedney for leadership, Fleet for grace'). Towards Boston from Spalding there are more fine towers: Pinchbeck, that looks as if it is trespassing from Somerset; Surfleet that leans so much that you hurry past in case it should drop on you, and Swineshead with stone spire and pinnacles. North of Boston, and north-west towards Lincloln, there are

more, as far as the Fens reach. There are always spires and tower to be seen in this green world of reeds and long grass, of outlying farms beside dykes, and scattered Dutch-tiled villages – and cramping bungalows. The spire at Long Sutton was covered with lead when it was built in the thirteenth century, and after seven hundred years it has become a magical grey-white colour. It plays tricks with the sky in many lights, now pointing a white finger into a deep blue expanse, and now getting almost lost against silver-grey clouds, making its presence known to the eye only by its criss-crossing diagonal ribs with delicate shadows under them.

At Gedney the tower is a tall rectangle of stone with very small angle buttresses, the whole welded by the marsh winds and rains into a solid mass. The lowest stage has a small lancet in each face, and from here upwards the arcading and the windows in each stage grow bigger and more elaborate. The early English work at Gedney was stopped half way by the Black Death, and the Decorated top stage is a masterpiece of tact: dashing and personal, yet full of reverence for the work below. From Fleet, a mile or so away across the Fen, the dignity of Gedney tower is quite as impressive as when you are standing close beside it. It dominates the marsh by its height, and yet in many lights it is spectral, because its colour is absorbed in the expanse of bright grass and waving reeds. At Fleet the tower is detached and stands among tall poplars that it dwarfs. It has a stone spire with delicate flying buttresses, and the tower is heavily buttressed at the corners. Sunlight gives the base a deep contrast of light and shade, from which the spire rises into clear air.

Plate tracery and blind arcading are much used in these towers, because they were a means of moulding and decorating the solid-looking, sculpture-like surface of the mass that had been set on the marsh without punctuating it too much with the holes of windows. Cotman's etchings of West Walton and Walsoken show that he saw this point, for he accentu-ated the boldness of these features, and in the etching of West Walton he heavily shaded one side of the tower, to show how solid it looked, in spite of the fierce scoring of the arcading.

Erratic and indefinite, the colour of the East Anglian towers has defeated most painters. But Cotman fixed it by looking at Norfolk towers for a lifetime, and then putting down a pictorial précis of the information his eyes had collected for him. Grey and gold and brown, and sometimes none of these, the towers are always afloat on a sea of Fen-green. Changeable skies give them bodies of infinitely varying light, sometimes pale and almost white against heavy clouds and shadowed marsh, sometimes burnished, sometimes glimmering, sometimes vivid, sometimes dim.

Architectural Review, vol. 88, November 1940

THE PRACTICAL BUSINESS OF PAINTING

Nobody but a rash man, in these days, tries to make universal rules about painting and I think an individual painter can only profitably speak from his own practical experience, which has not necessarily many points of contact with the practice of others.

Subject

I am a painter and draughtsman of landscape and architecture. I am more fitted by birth and environment to enjoy painting such subjects than any others. And since painting is physically and mentally an arduous task it is necessary to have every encouragement – like this enjoyment of subject – if you are going to persist in it for long. Otherwise, as with any other full-time job that you think about most of the time, when you are not actually working, as well as when you are, you are likely to get bored and irritated, and to dissipate your energies, whenever the opportunity occurs, in relaxations. And you soon begin to make such opportunities.

My parents and grandparents were country people and I was born in the country; and I have always had an interest in architecture, having looked at old churches, houses and villages, and read guidebooks, since childhood. So to choose other subjects – such as portraits, which are more than a full-time job, demanding special capacities of insight into human character – would be in the end to go against my natural bent.

This does not mean that I paint landscapes and architecture all the time. Doing that, it would be easy to get into a rut. For doing exactly what you think you like all the time makes you feel in the end that nothing at all is worth doing.

For five years, I painted nothing but abstract pictures, which I found a good discipline: especially then, ten years ago, when there were so many 'directions' and 'isms' that it was difficult for a student to know which way to turn. I found abstract painting helpful because it taught me something of the values of clear colours, one against another, when they have no goods to deliver except themselves. Some colours seem to advance in front of other colours, others seem to retire; some 'kill' others, while some seem to make others more vivid.

Why artists draw from the nude

But I think the best subject for a student to return to (and a good painter always, in one sense, remains a student) is the nude. Because, in the human figure you can find simple forms and subtle forms combined better than in any subject. Also, because you can easily recognise any positive mistakes you make when you draw and paint it. If you draw a tree and add a big branch that isn't there, or add two or three big branches, so long as they join on to the trunk properly, nobody is any the wiser. But if you make a head too big for a body, let alone adding an extra leg to the human trunk, you can see what you have done at once; and you have done it for one of three reasons – you tried, and failed, to get it 'right', you did it to be funny, or you did it for some symbolic purpose. The human form, to humans, is the best-known and most easily recognised form of all, which means that we notice more of the subtle variation in it than any other form. One sunflower is much like another sunflower, except perhaps to a botanist; but we all recognise one human being from the next.

But, in general, for me, the subject is landscape and architecture. I believe it is necessary in these days, to like, and even if possible to love, your subject: 'in these days' because there is a great deal of hate about, and there are many temptations to paint 'hate' pictures. In the past 'hate' pictures have by no means always been bad pictures, but to-day the artist, in so far as he is a leader, has an urge to counterbalance, rather than to increase, hatred.

Treatment

I am not interested in 'copying' what is in front of me. I find copying pictures very useful and enjoyable up to a point, but copying nature is a different affair. It is, at the best, a dull occupation, though I much enjoy using

a camera, and find photographs of people and places a good jog to the memory: and they can help you to see and record things in a fresh light, or an aspect that had not struck you before. Naturalistic painting can, probably, do the same thing; but it would seem to me a duller occupation than any of the crafts such as weaving, or basket-making, or thatching, or brick-laying. 'Good' painting has never been naturalistic painting. What is it, then? That is not so much a mystery as a thing it is impossible to describe in words, though a good critic – a rarity – will sometimes suggest what it is. Good paintings in the long run tell their own story – though not in words – to those who have intent eyes, an open mind, and much patience. There is no quick, and no other, road to being able to tell a good painting from a bad one.

The nearest I can get to describing what I try to do in painting is to say that I want to make a pictorial parallel for what I see, complete in itself and yet derived from nature – a lively symbol that seems to belong in a picture frame. I know when I have done it, up to my own limit, but it is never completely satisfactory to me; and I always go on trying to do better. After a time you get interested; it becomes an absorbing occupation, and you cannot stop.

Method
I draw in pencil, black and coloured ink, chalks (both pastel and greasy-crayon kind), water-colour, gouache and oils. All except the last I sometimes combine in one work. I see no reason why gouache should not be combined with water-colour in the same work, though it is against traditional and conventional practice. In oils, similarly, I often use glazes; that is, transparent colours thinly spread over a ground of white or another colour (I use colour on a rag, spread over a dry white under-painting). And these glazes can be happily combined with more thickly-painted areas. This, in oils, is one of the 'traditional' methods.

Though I have done much oil-painting out-of-doors in the past, I find the physical difficulties so great that I have almost given it up – though one can never tell; something might tell me to take it up again at once! But a canvas is unmanageable in a high wind, and proper equipment heavy to carry any distance. As a rule, I use inks and watercolours out-of-doors, sometimes adding several pages of written notes, or sketched notes, about colours and tones, relative shapes and proportions of parts of a subject. All these I take home and, at leisure, with the aid of 'squaring up' (making relatively-sized squares of the same number on the original drawing and on the larger canvas), and with the aid, too, of all the paraphernalia of a home-studio (easel, brushes, turpentine and linseed oil, large palette of glass or metal, rags, constant and well-known light) paint in oils from them. The careful deliberation allowed by working later in the studio gives me time to reconsider, and make more careful and leisurely statements. One can lose 'freshness' doing this, but 'freshness' belongs to the out-of-doors sketch, probably; and sometimes this is complete enough in itself.

The trouble is to keep up a really interested feeling for your subject and painting, letting one play itself off against the other. Sometimes it seems to me that the ability to do this constitutes the whole of the art.

An extract from *The Artist and the Public* published in *Current Affairs* No. 96, June 2nd 1945 by The Army Bureau of Current Affairs

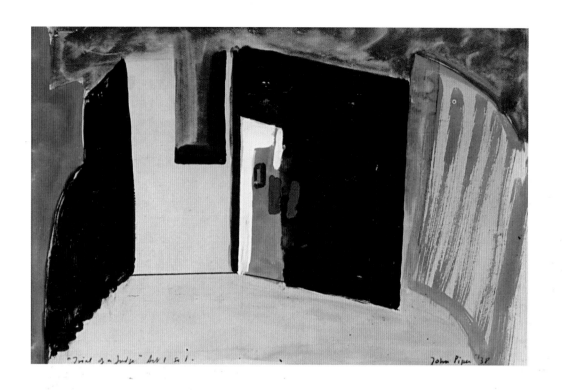

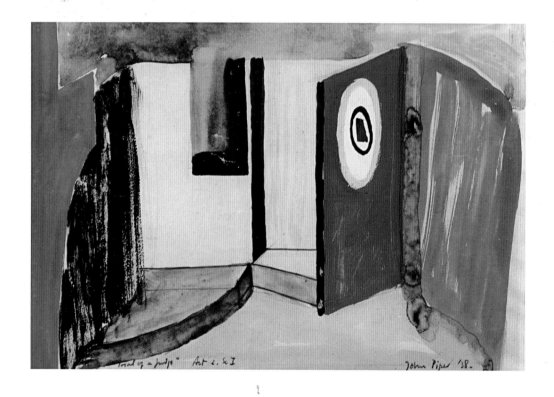

11.
Two Designs for
'Trial of a Judge'
1938

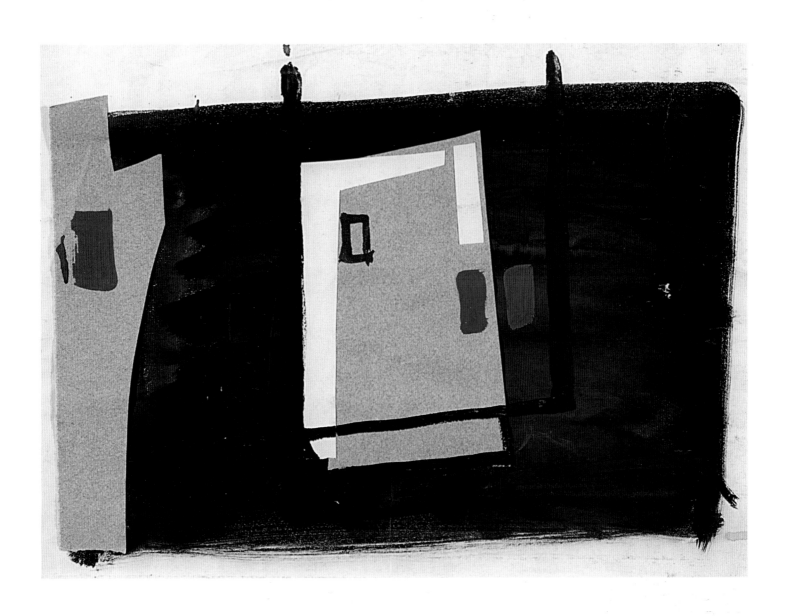

9.
Design for
'Trial of a Judge'
1938

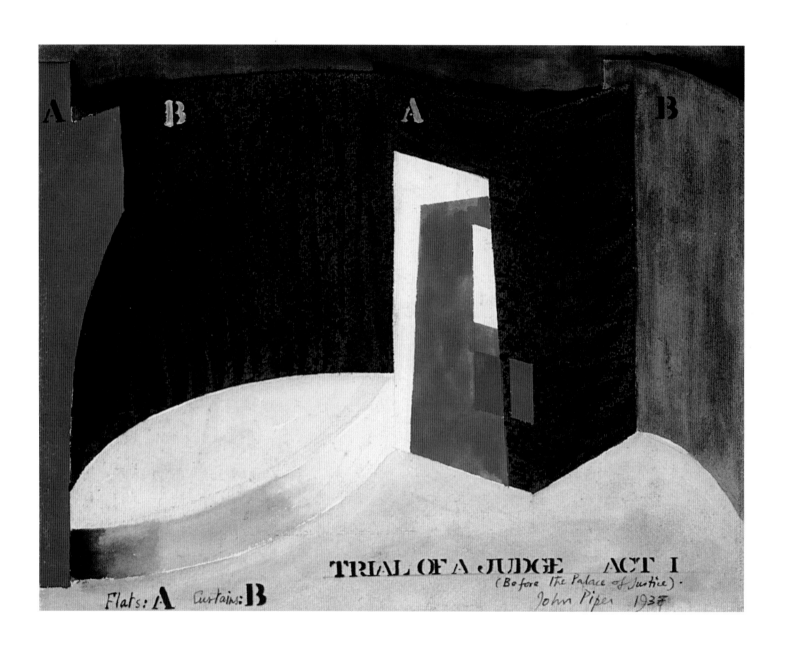

7.
Before the Palace
of Justice
1938

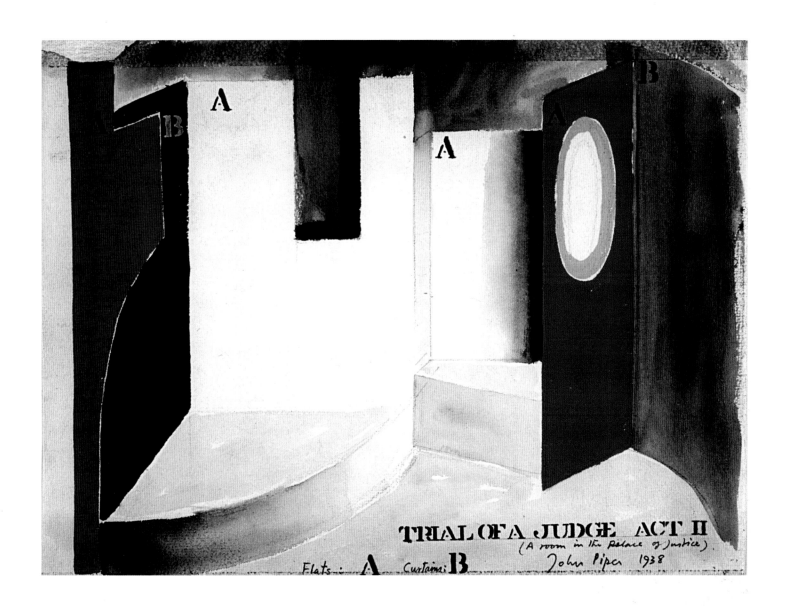

8.
A Room in the Palace
of Justice
1938

Beach Object
photograph by
John Piper
1937

1.
Forms on a Green
Ground
1936

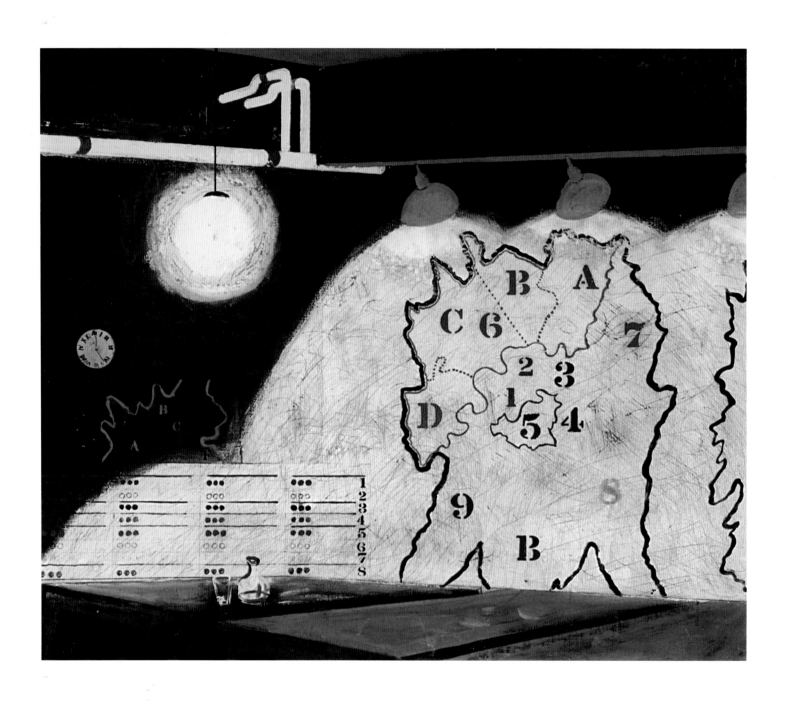

18.
The Control-room at
South West Regional
Headquarters, Bristol
1940

19.
*The Passage to the
Control-room at
South West Regional
Headquarters, Bristol*
1940

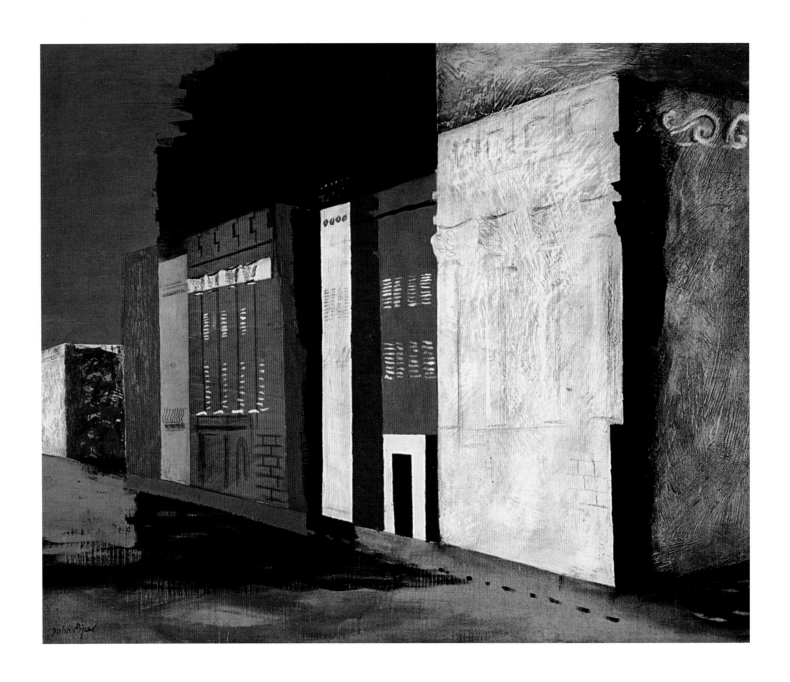

12.
Dead Resort,
Kemptown
1939

16.
Cheltenham Fantasia
1939

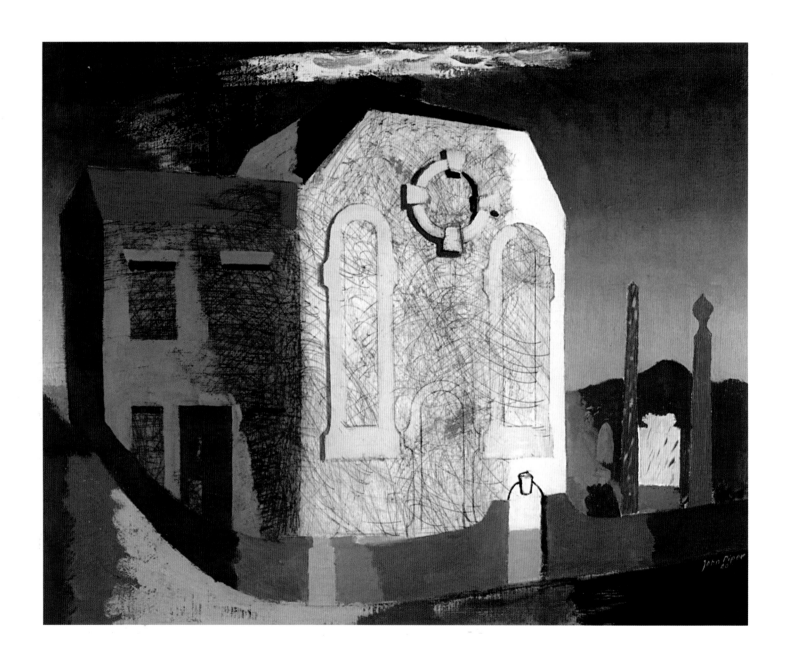

15.
Gethsemene,
Cardiganshire
1940

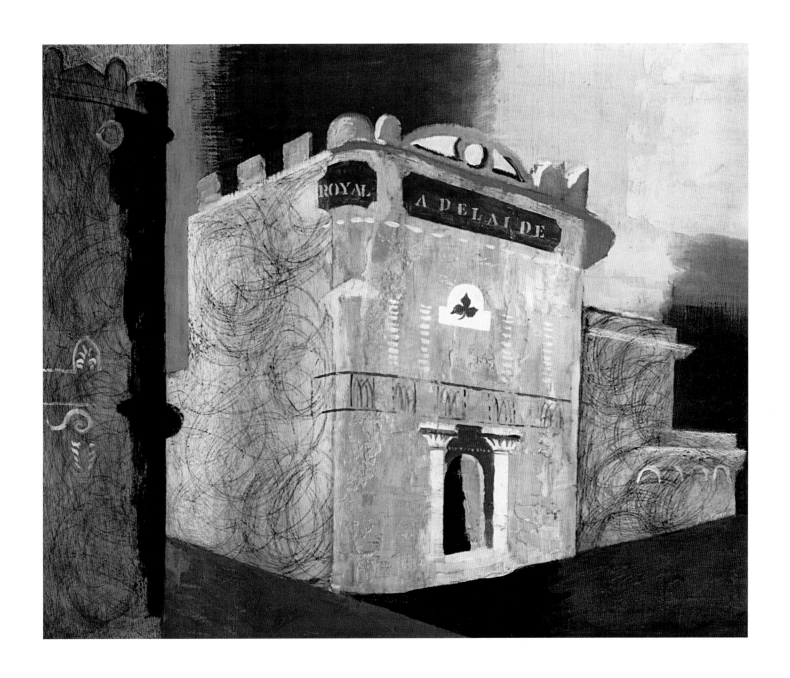

13.
Royal Adelaide:
A Simmons House,
Windsor
1939

14.
*The Octagonal
Church, Hartwell*
1939

20.
*The Barn at Great
Coxwell*
*c.*1941

21.
Tombstones at Holy
Trinity Churchyard,
Hinton-in-the-
Hedges, Northants,
September 1939
1939

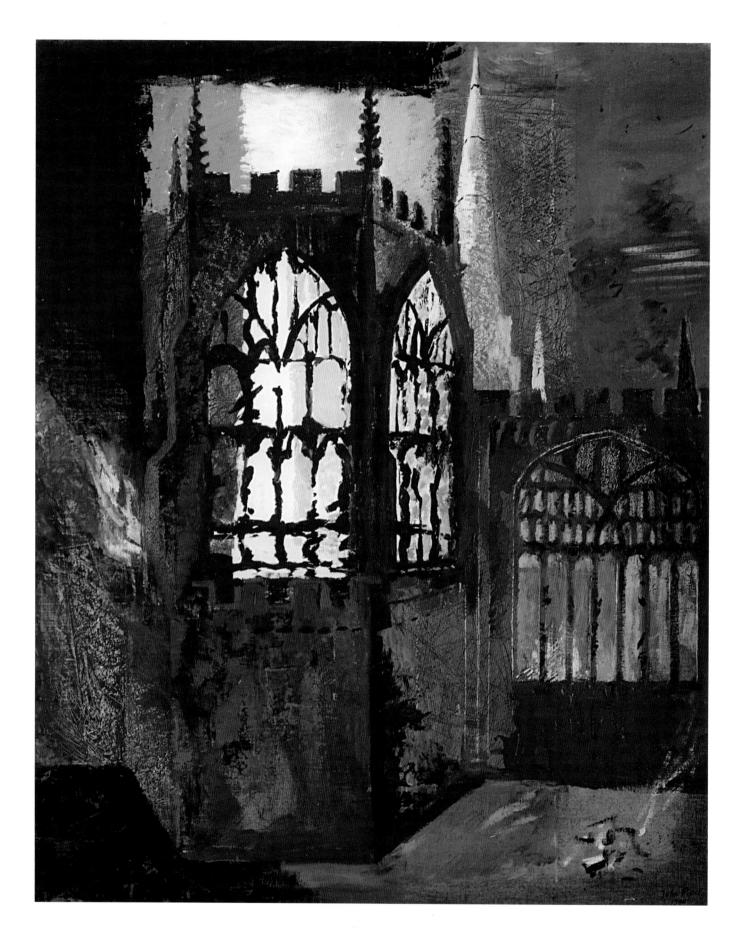

22.
Coventry Cathedral,
15 November 1940
1940

36.
Coventry Cathedral
1940–41

32

34

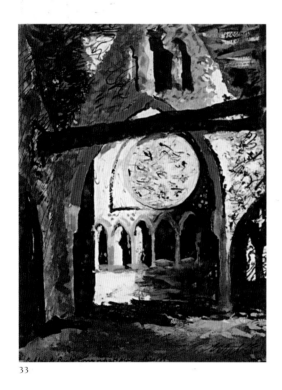

33

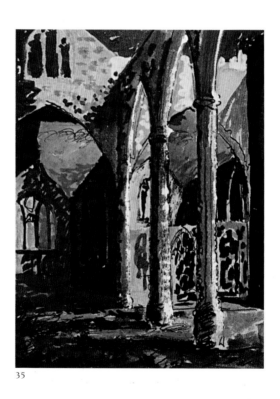

35

32.
*St Mary-le-Port,
Bristol*
1940–41

33.
*Redlands Park
Congregational
Church, Bristol*
1940–41

34.
*St John's Waterloo
Road, London*
1940–41

35.
*The Temple Church,
Bristol*
1940–41

24.
*St Mary-le-Port,
Bristol,
November 1940*

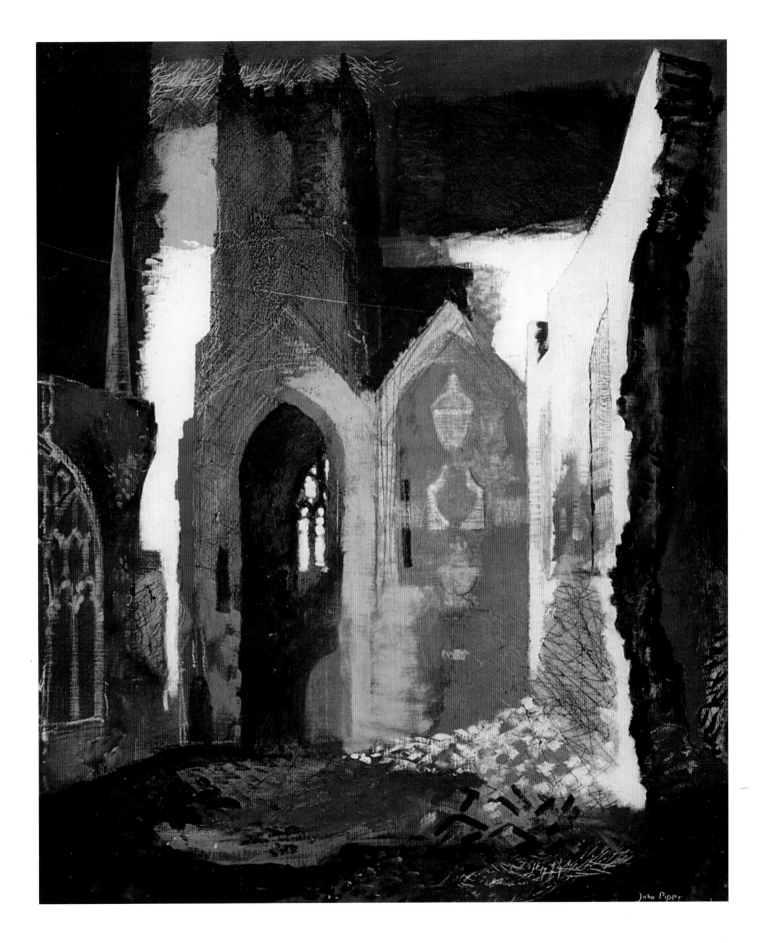

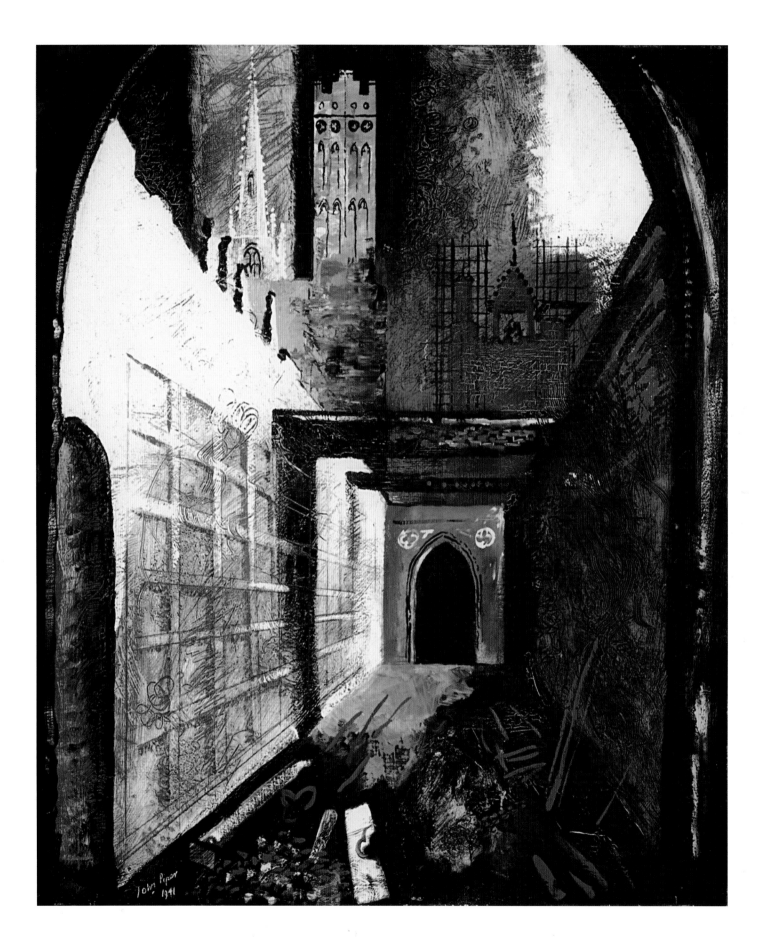

28.
House of Commons
1941: Aye Chamber
1941

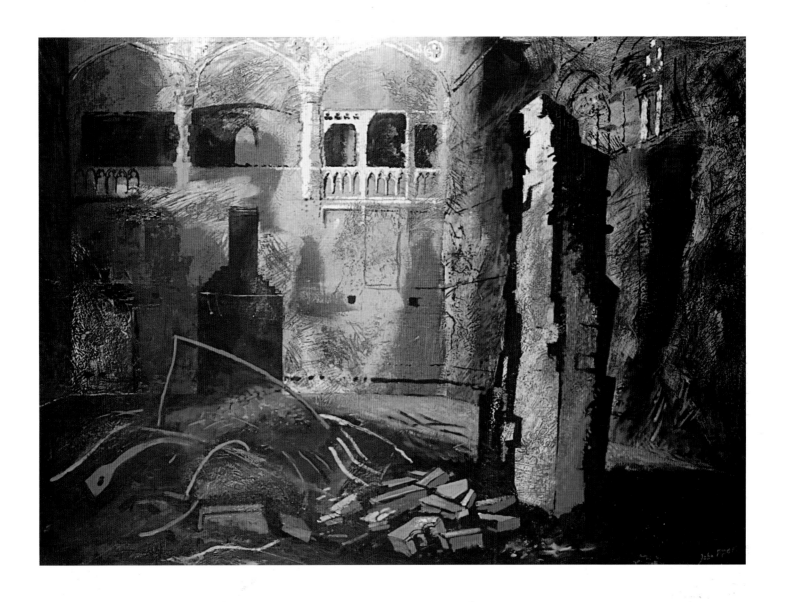

27.
The Ruined Council
Chamber,
House of Commons,
May 1941
1941

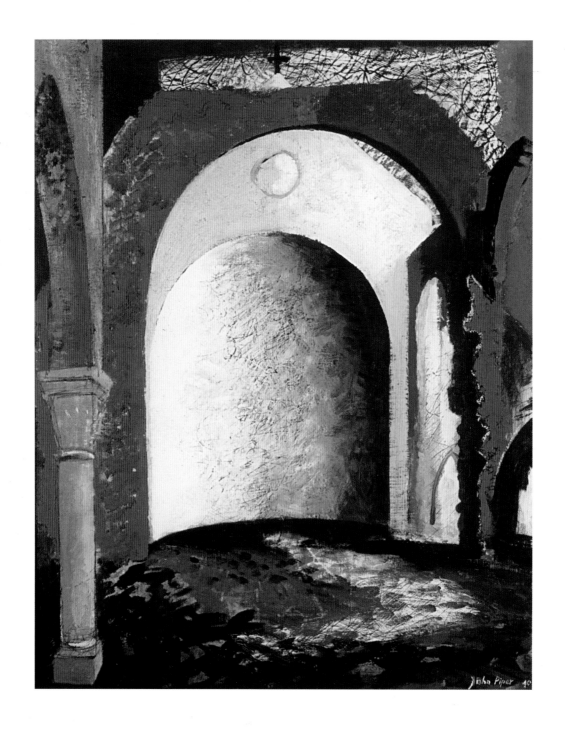

25.
*Church of the Holy
Nativity, Knowle,
near Bristol*
1940

26.
*Christ Church,
Newgate Street, after
its destruction in
December 1940*
1941

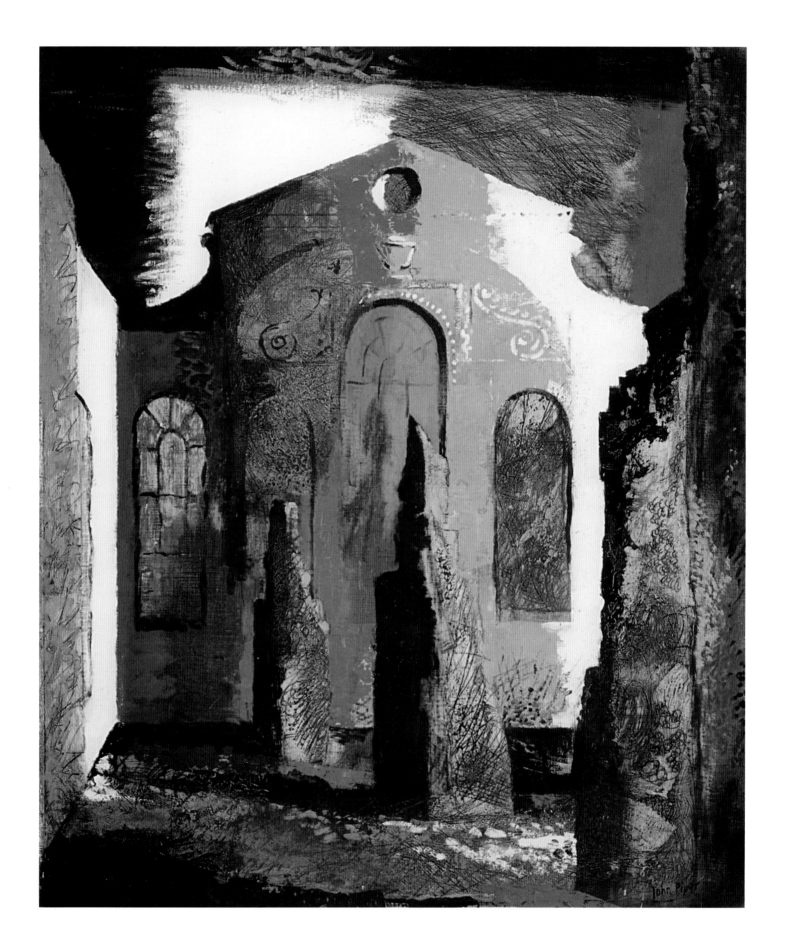

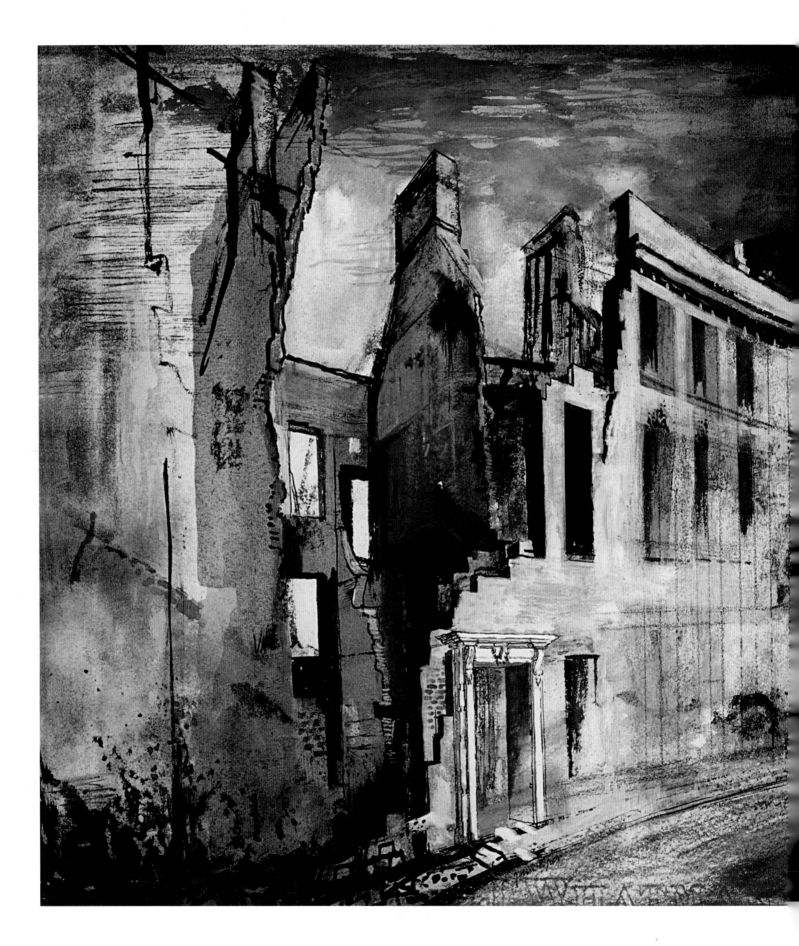

30.
Somerset Place, Bath
1942

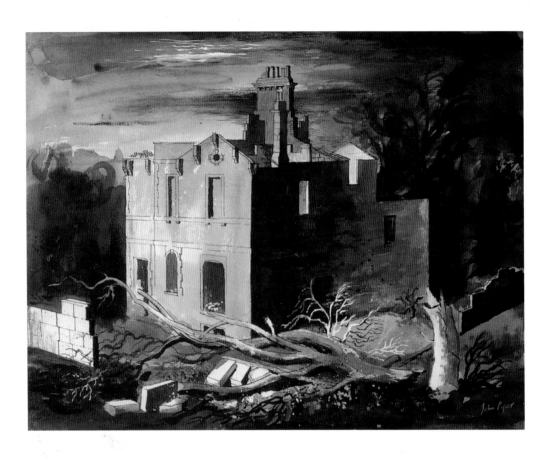

31.
Ruined Victorian House, Lansdown, Bath
1942

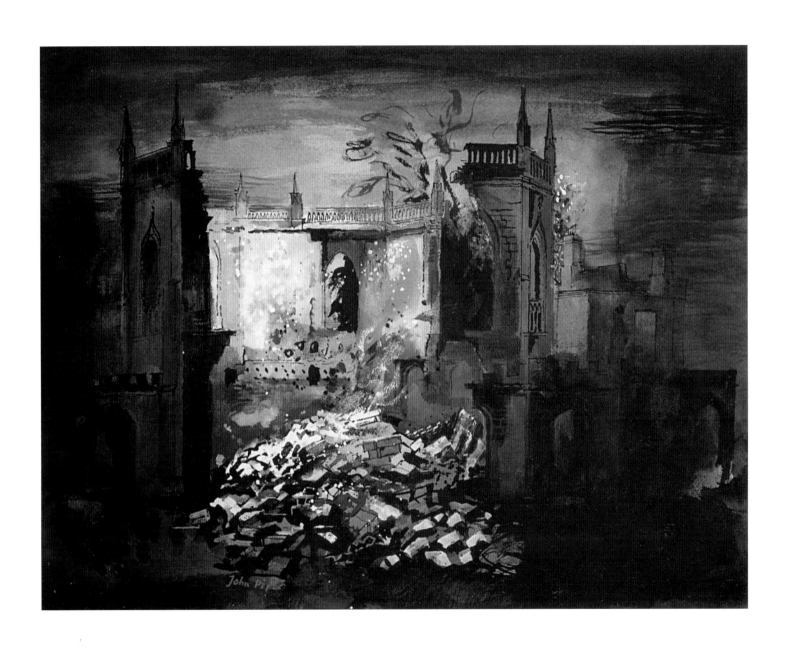

29.
All Saints Chapel,
Bath
1942

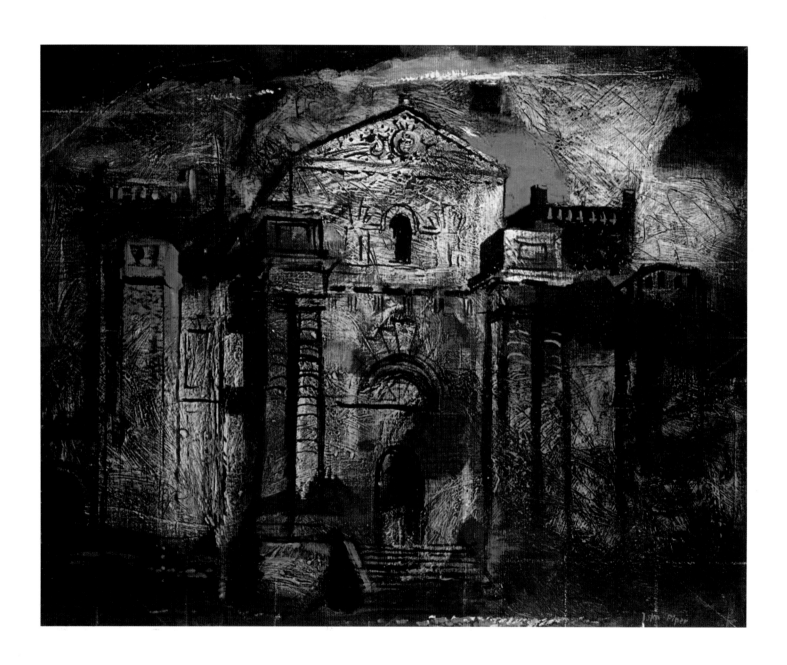

40.
Seaton Delaval
1941

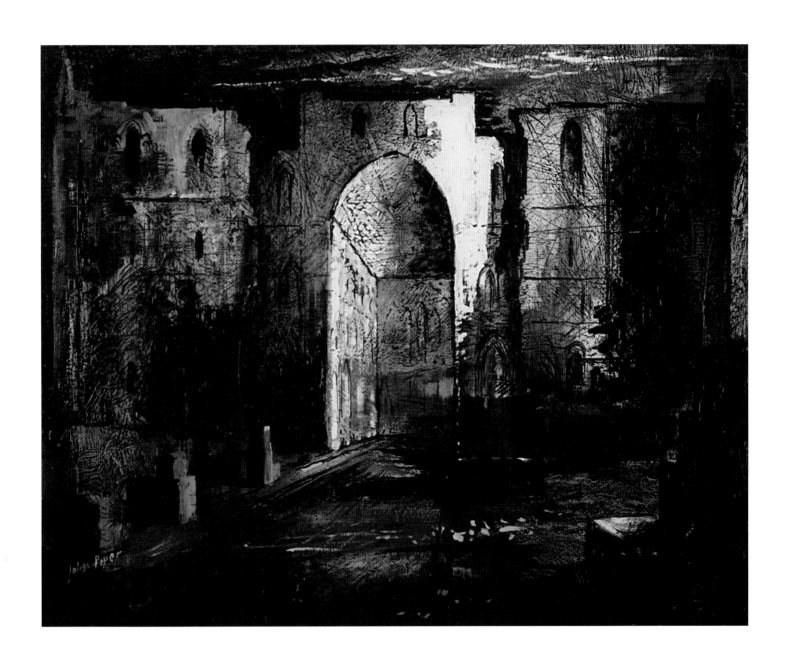

42.
Rievaulx Abbey
1942

38.
Holkham, Norfolk
1939–40

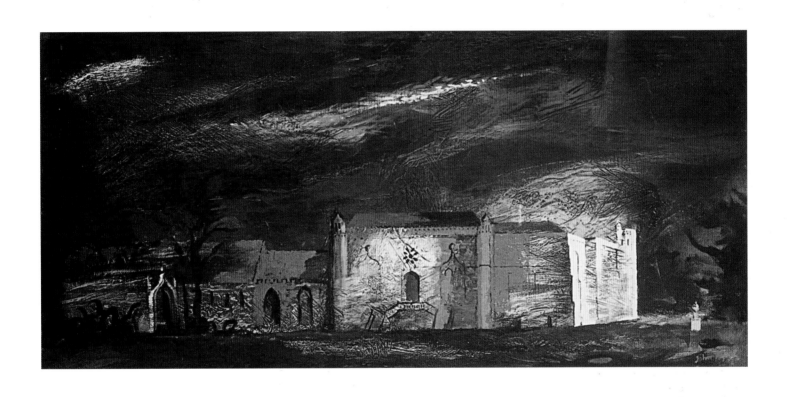

41.
Lacock Abbey
1942

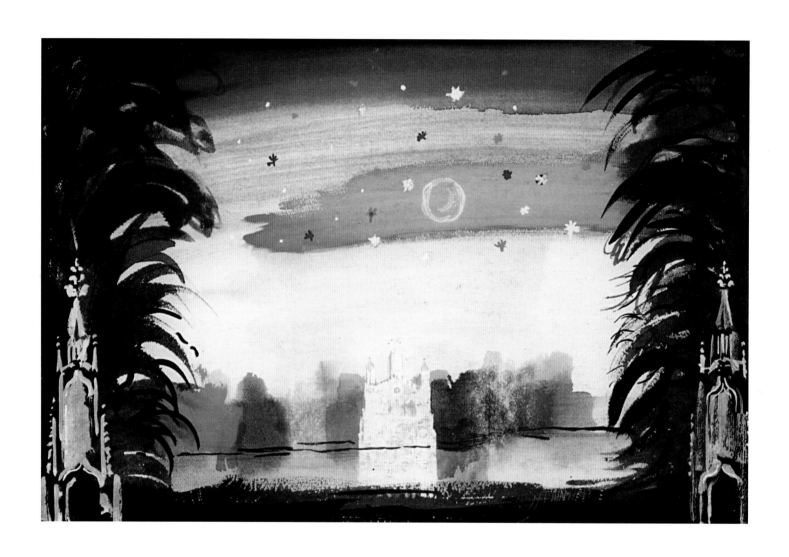

46.
The House of
Holinesse
1943

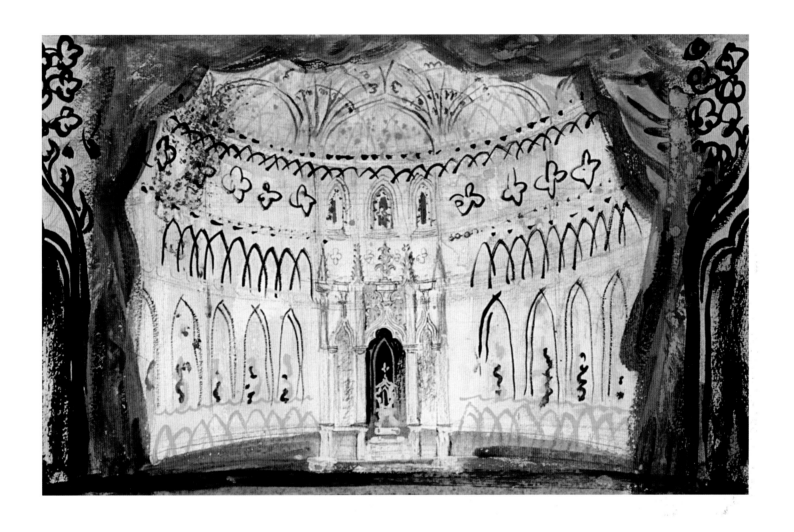

44.
The House of Pride
1943

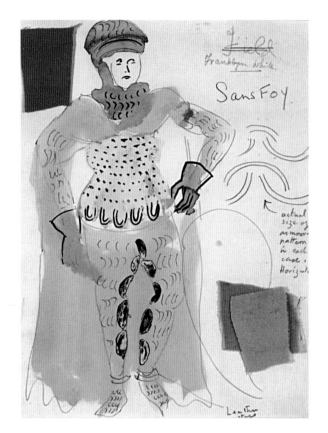

49.
Sans Foy
1943

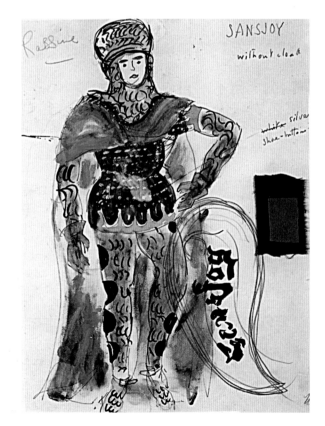

50.
Sans Joy
1943

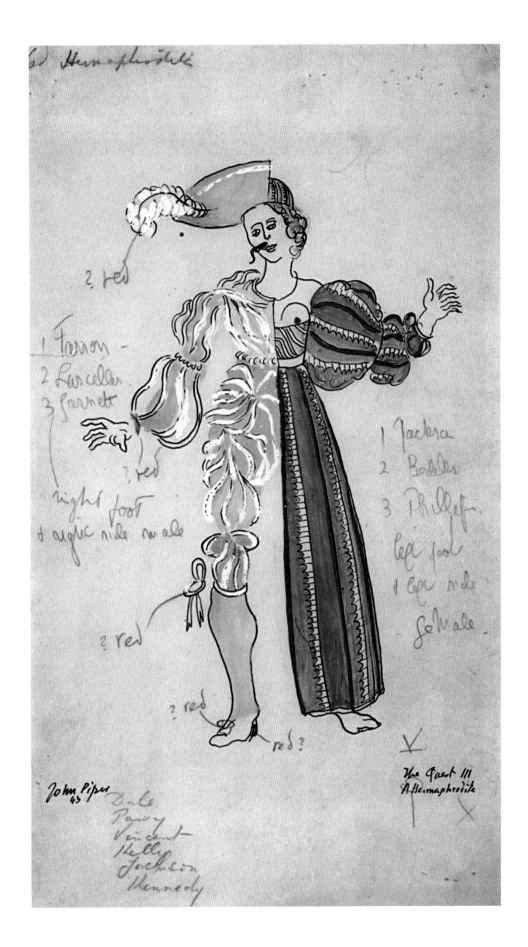

48.
The Hermaphrodite
1943

45.
*The Place of Rocks
near the Palace of
Pride*
1943

43.
The Magician's Cave
1943

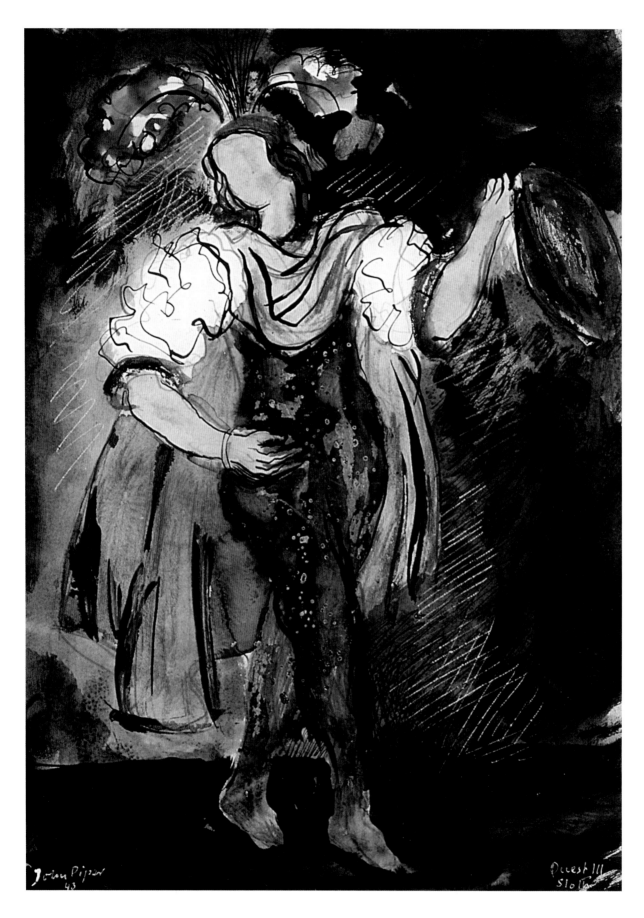

47.
Sloth
1943

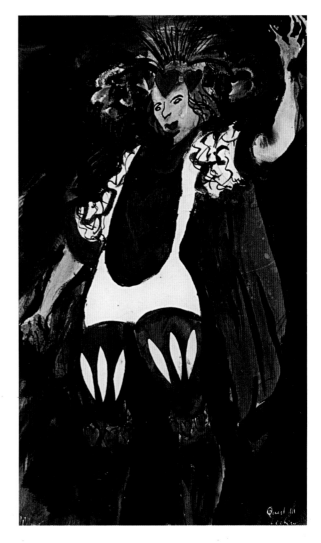

47.
Lechery
1943

47.
Wrath
1943

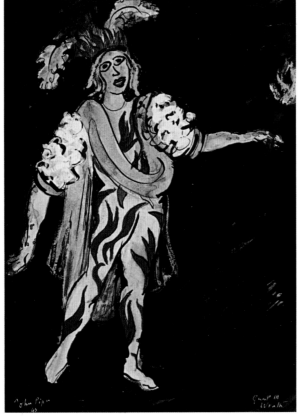

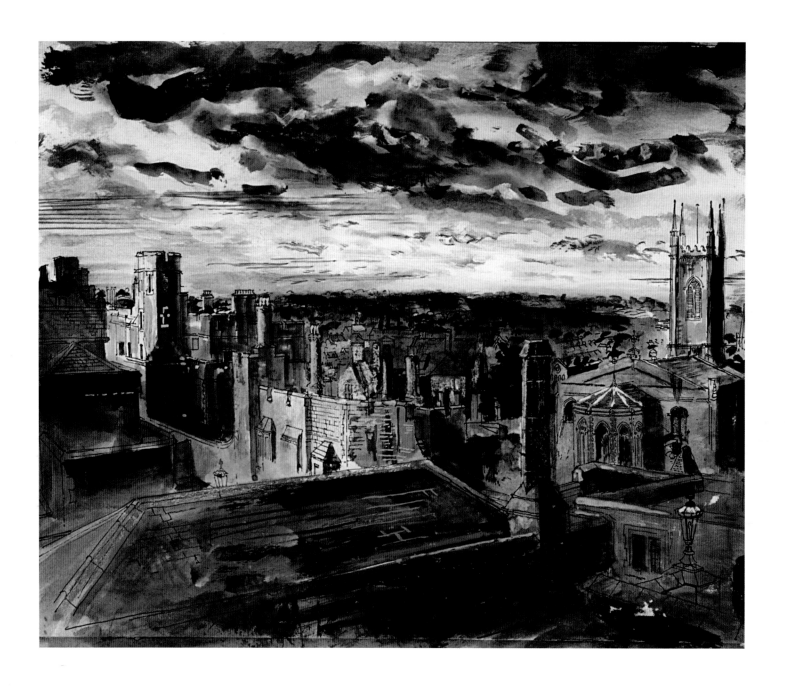

62.
The town of Windsor
from the Castle
1942

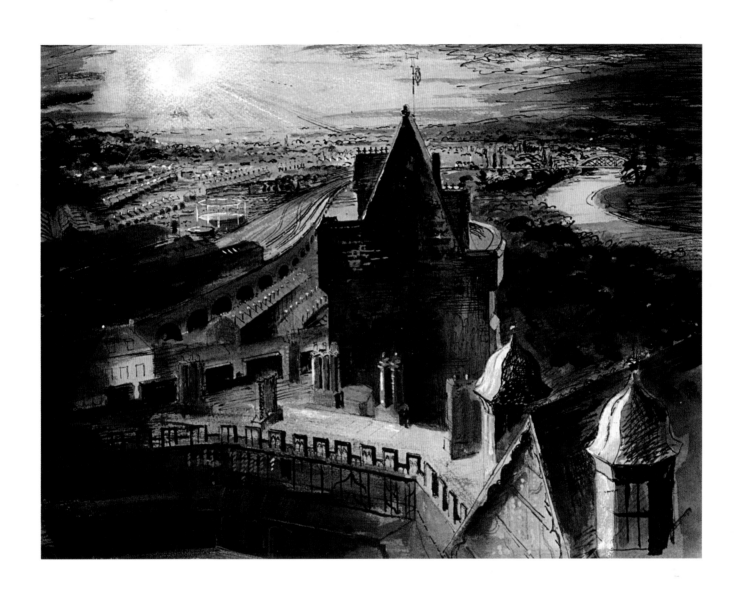

59.
*View of Windsor
town and the river,
and railway from the
Curfew Tower*
1942

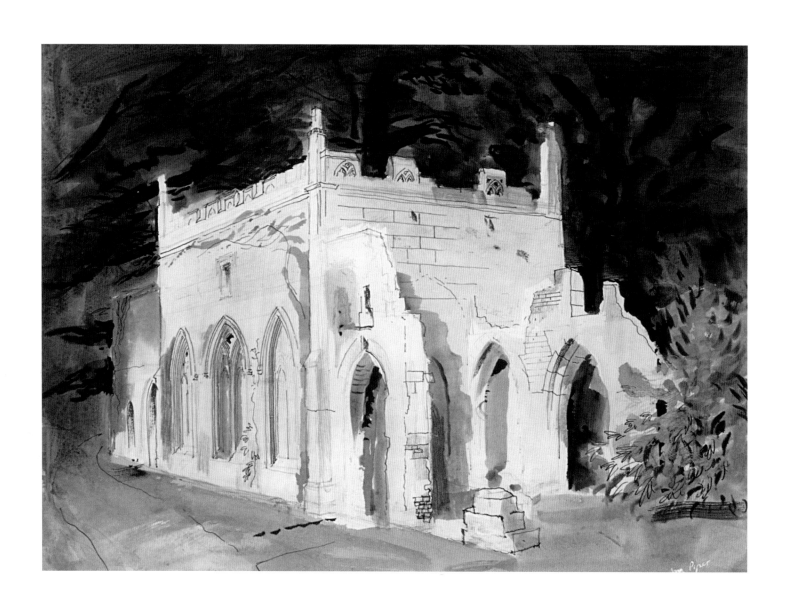

61.
Gothic Ruin,
Windsor Great Park
1942

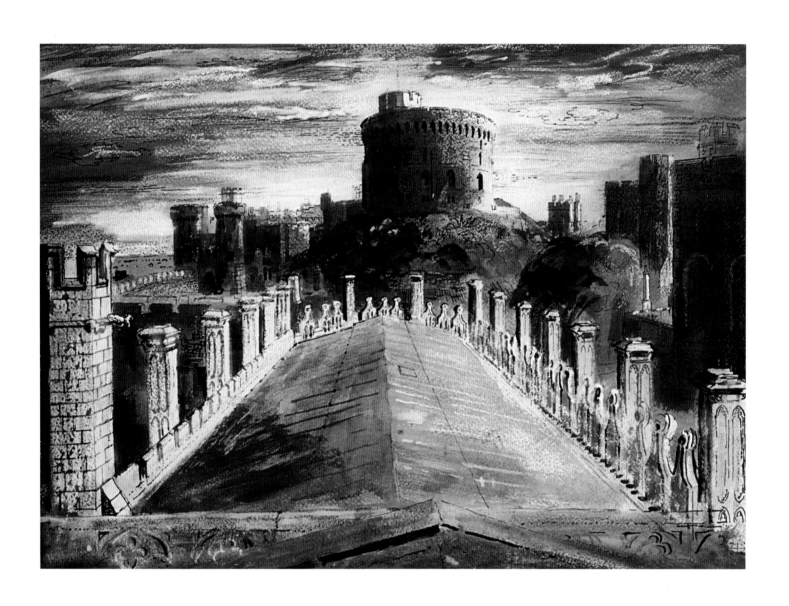

60.
The Round Tower
from the roof of
St George's Chapel
1942

55.
View of Knole
c.1942–43

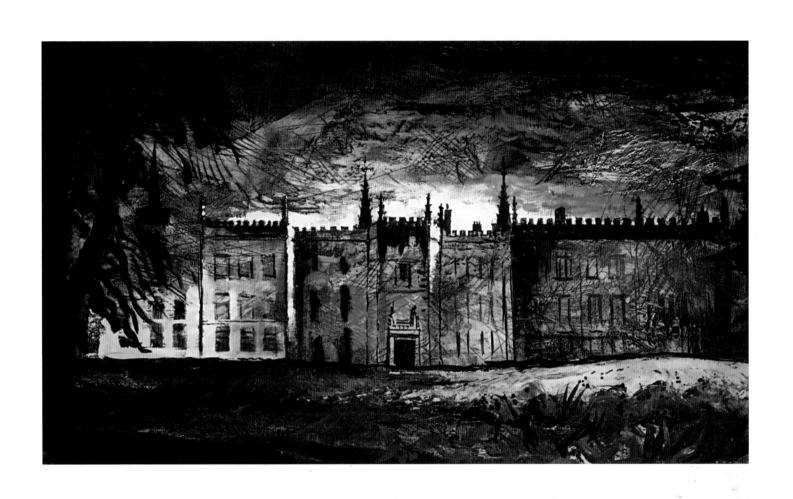

56.
Renishaw,
the North Front
*c.*1942–45

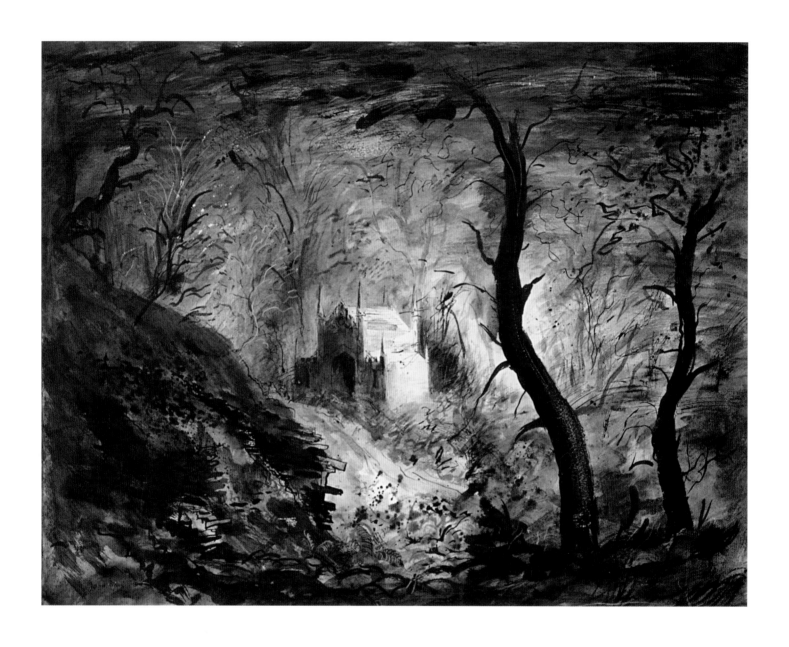

58.
The Arch in the
Ravine
*c.*1942–45

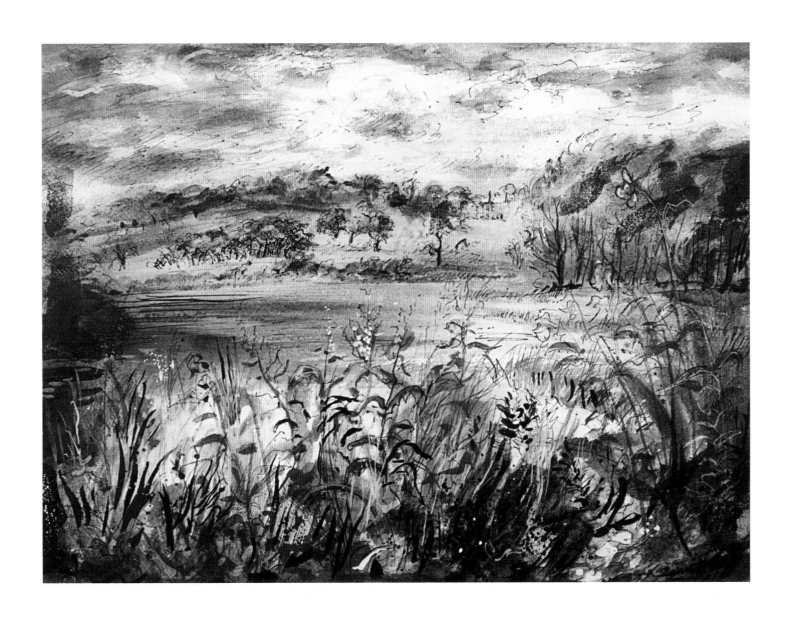

57.
The Lake in Summer,
Renishaw
c.1942–45

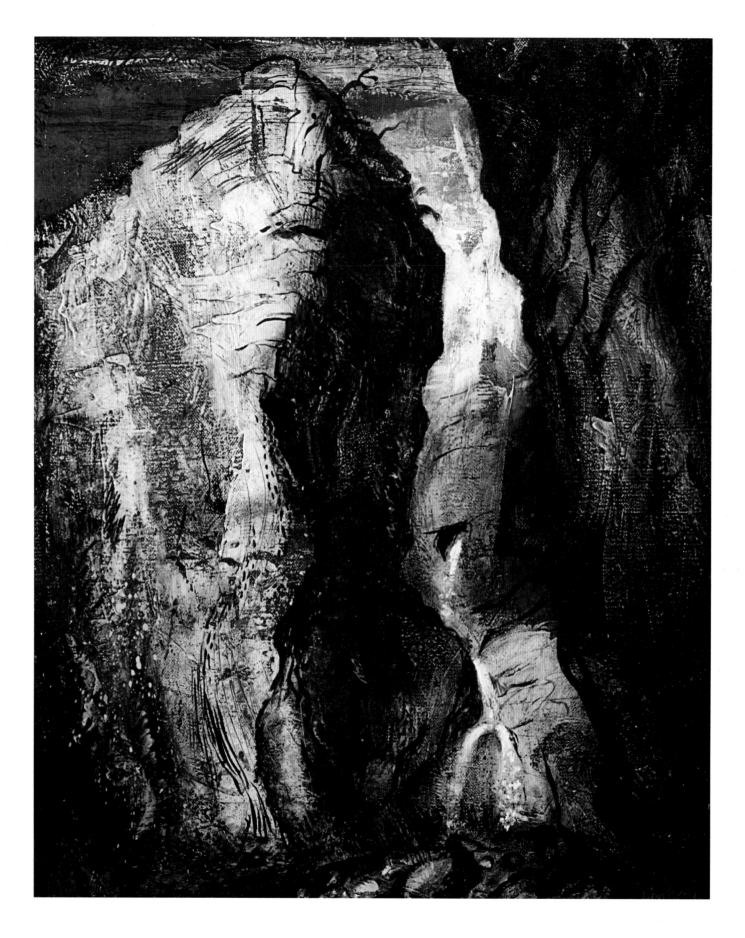

63.
Gordale Scar
1943

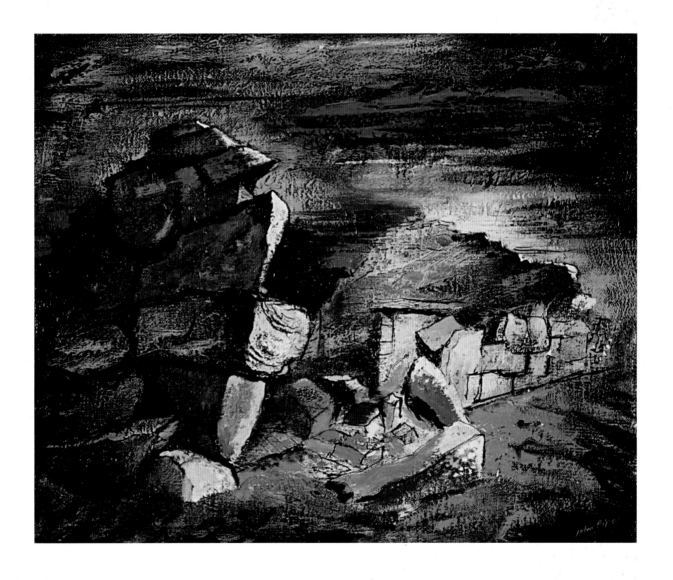

72.
Ruined Cottage,
Tomen-y-Mur
1943

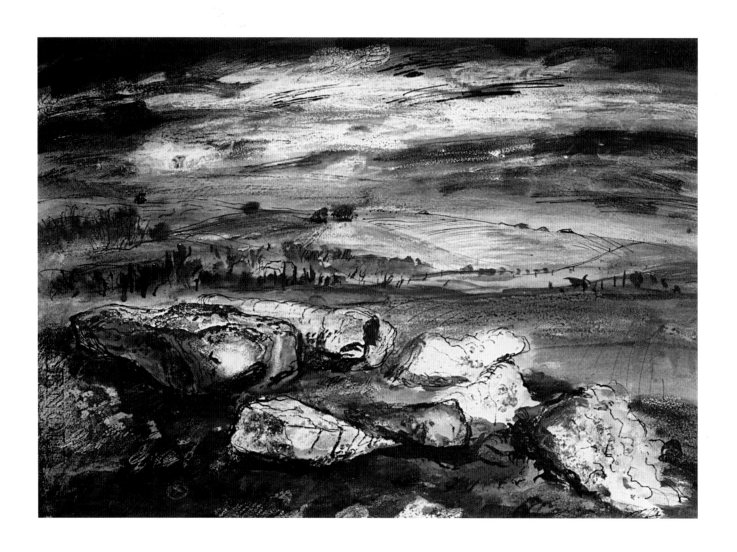

77.
View from West Kennet
Long Barrow
1944

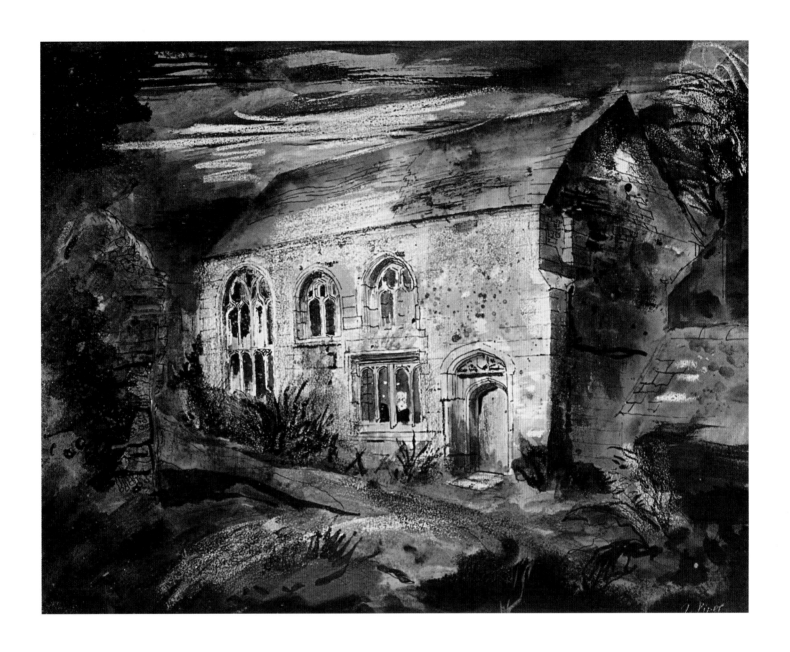

71.
Farmyard Chapel,
Trecarrel, near
Launceston
1943

64.
Weathercote Cave
1943

70.
A Wall at Mulcheney
Abbey
1941

68.
Derelict Cottage,
Deane, Hampshire,
March 1941
1941

110

66.
Nude
1942

67.
Nude Study
1942

65.
Two Nudes
*c.*1942

113

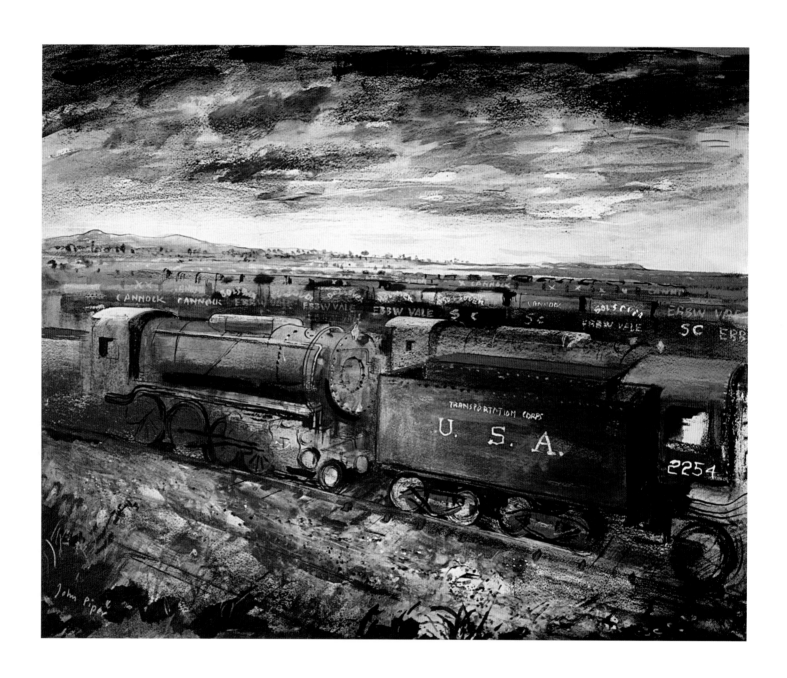

83.
*American locomotives
awaiting trans-
shipment on the
foreshore at Cardiff*
1944

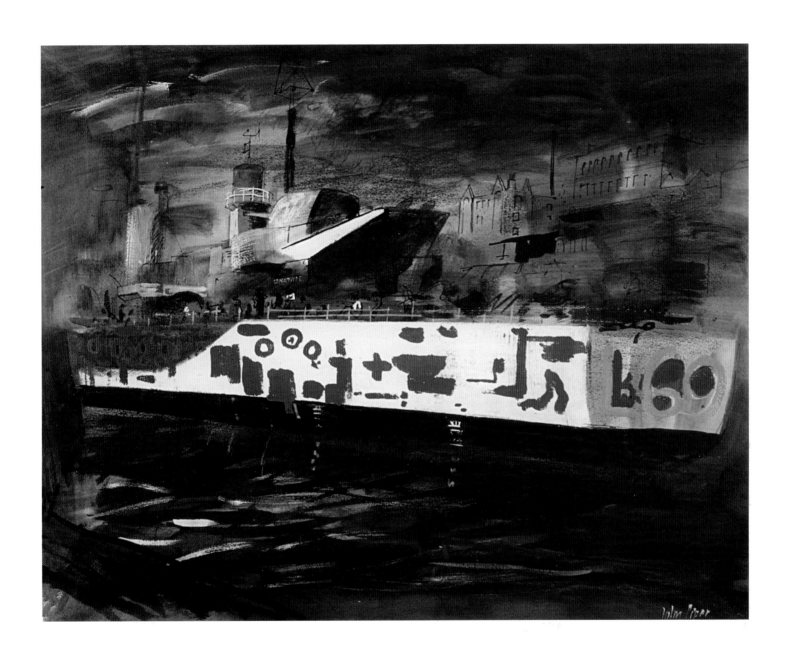

82.
*Repairing and
repainting warships
returning from the
beaches*
1944

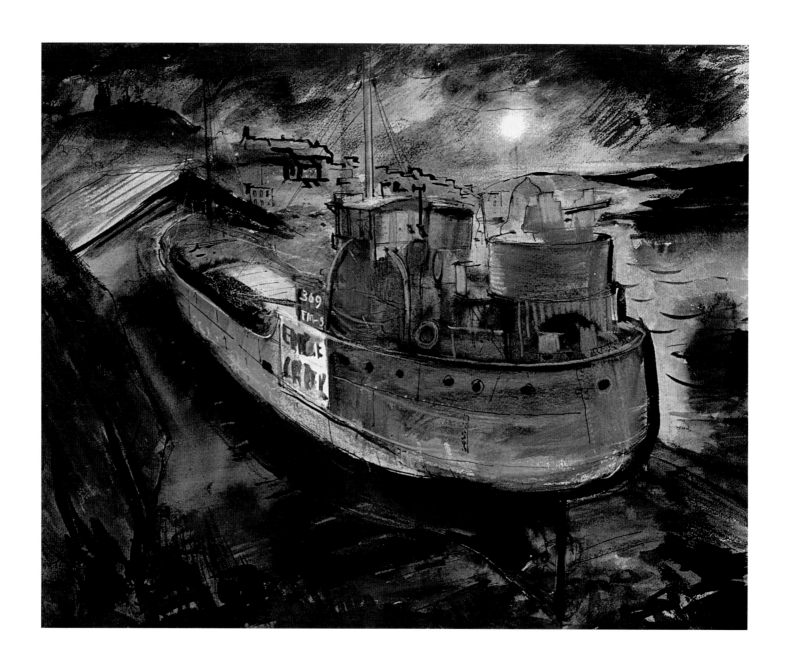

85.
*Ministry of War
Transport ('Empire
Creek') in dry dock at
Fowey, Cornwall*
1944

116

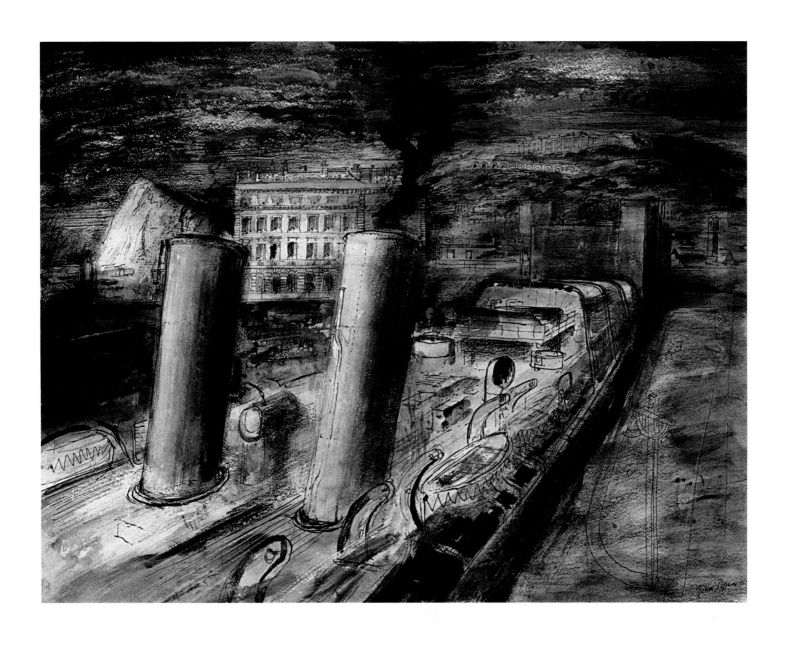

84.
*Train Ferry at Dover
Harbour*
1944

75.
*'Pink String and
Sealing Wax'*
1945

74.
'Painted Boats'
1945

73.
'The Bells Go Down'
Design for a film
poster (not used)
1942

79.
Moonlit Ruins (detail)
1942–43

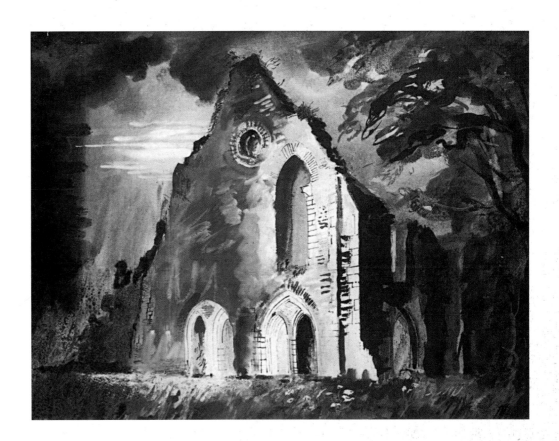

81.
Waverley Abbey
1942–43

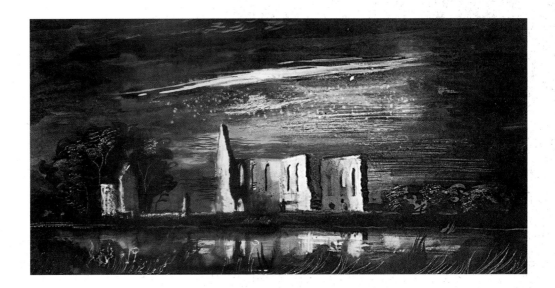

79.
Moonlit Ruins
1942–43

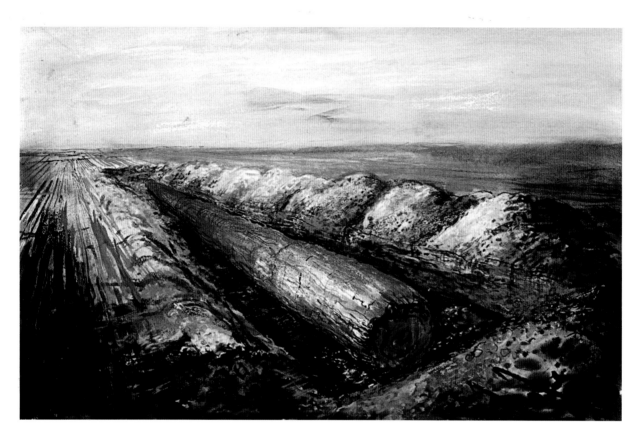

76.
Land Reclamation at
Swaffham
1944

91.
Glaciated Rocks,
Nant Ffrancon
*c.*1946–48

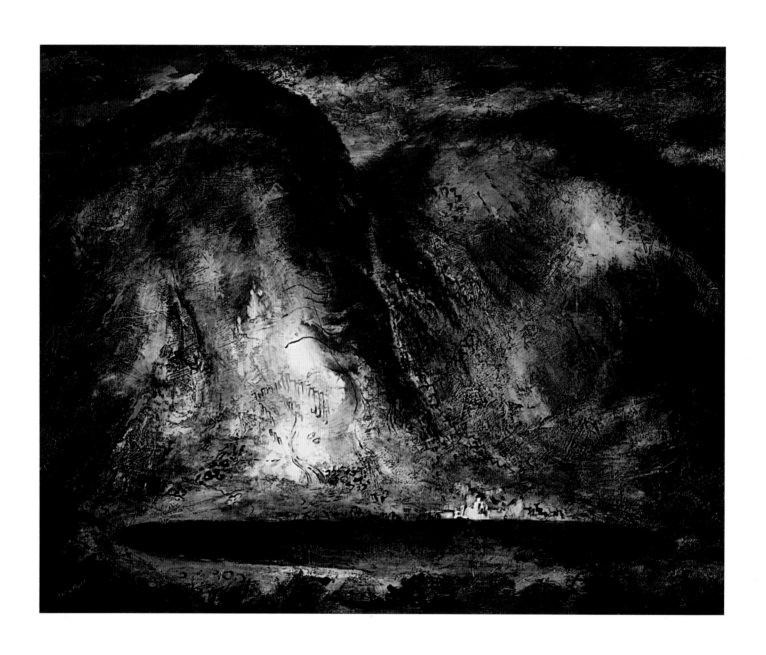

86.
The Rise of the Dovey
1944

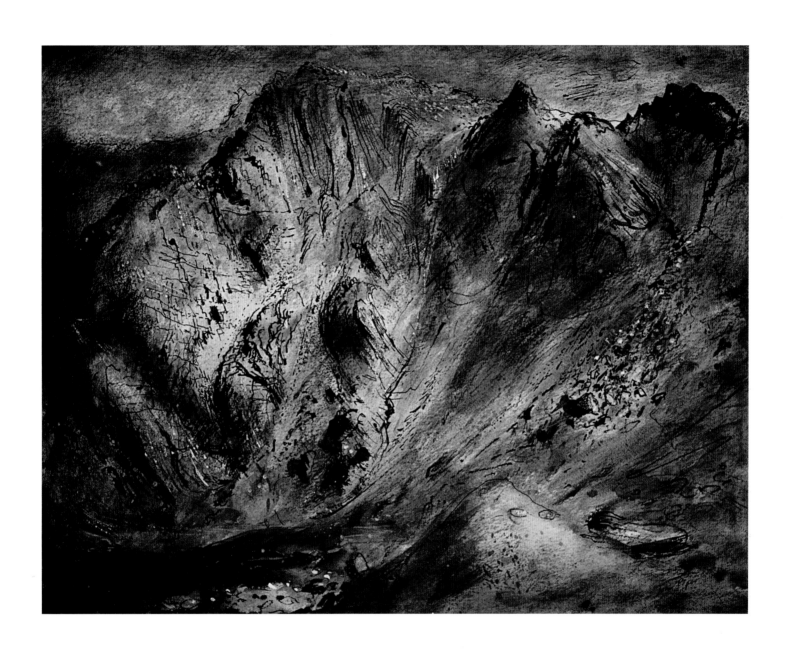

90.
*Slopes of Glyder
Fawr, Llyn Idwal,
Caernarvonshire*
1948

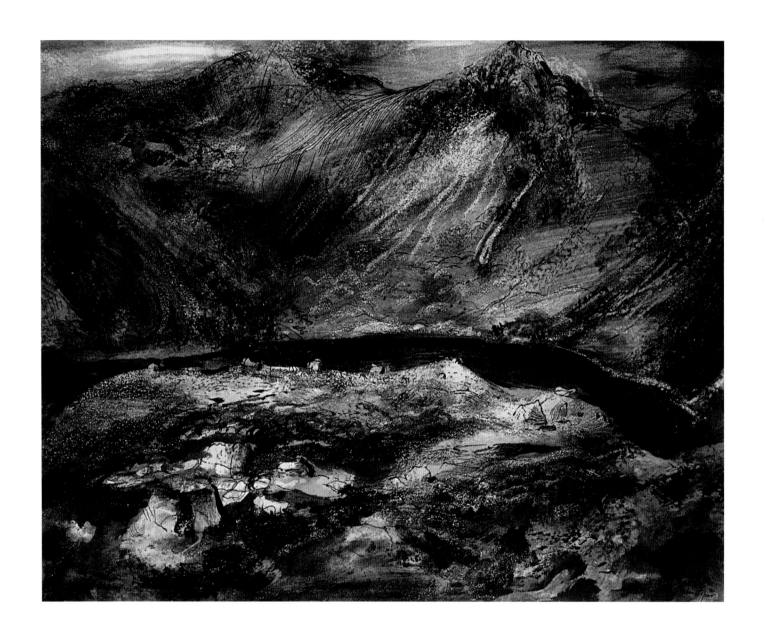

92.
Ffynon Llugwy
1949

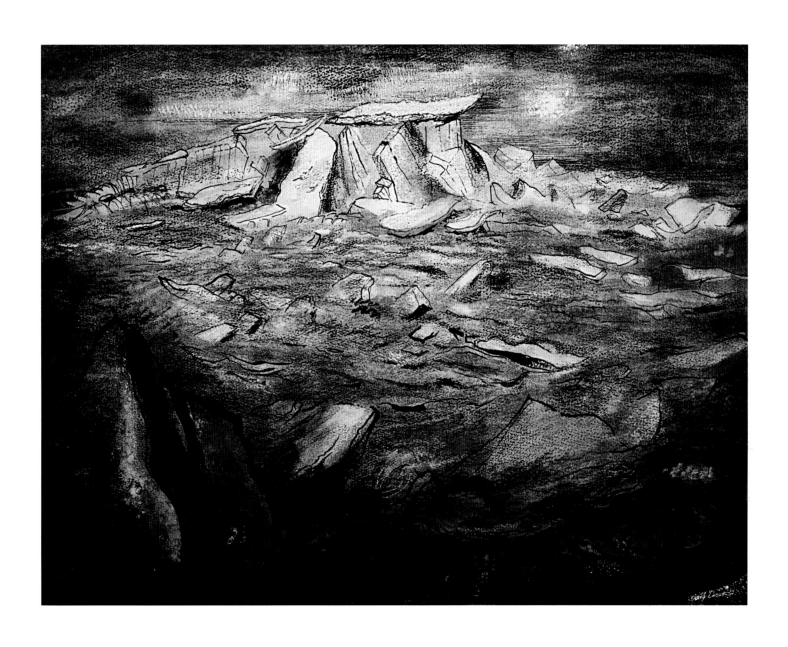

89.
Cwm Caseg
c.1946–48

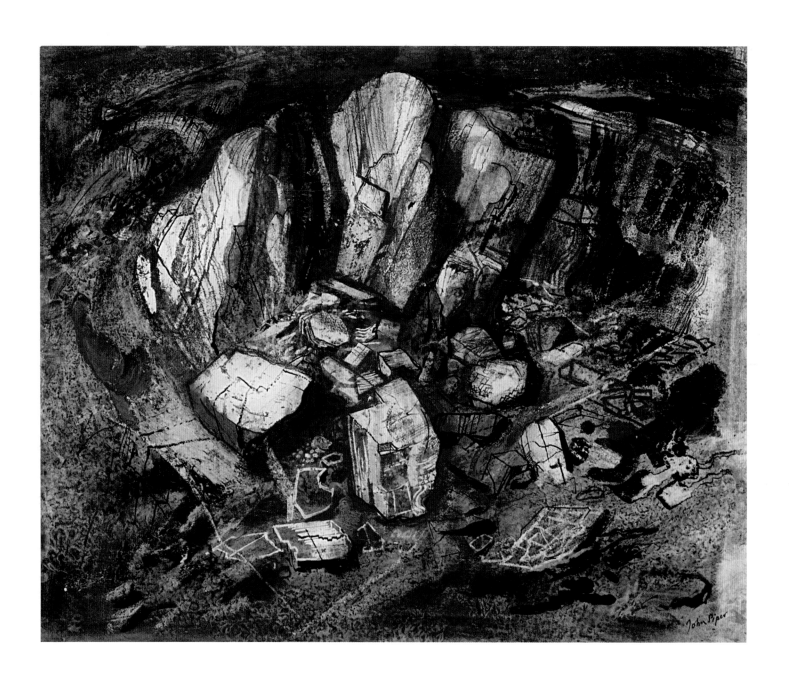

88.
In Llanberis Pass
1945–46

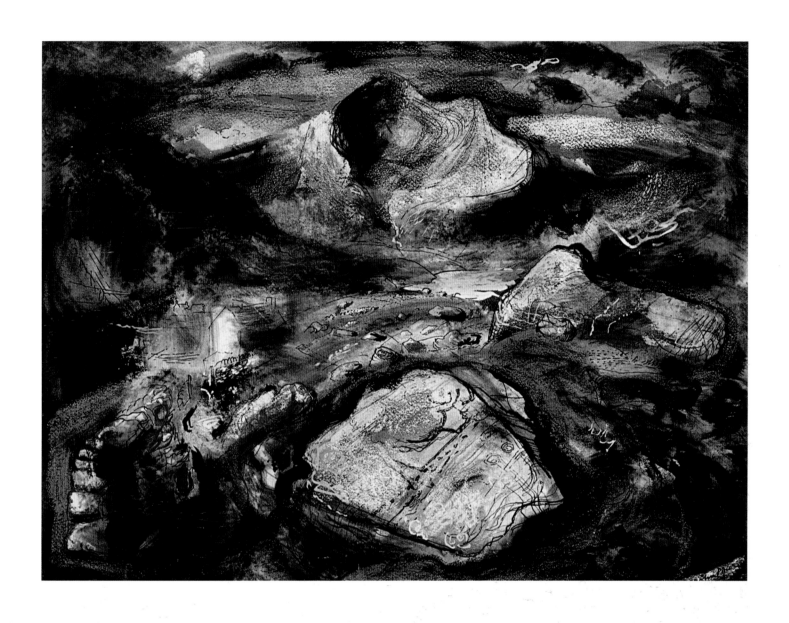

93.
Snowdonia,
North Wales
1945–49

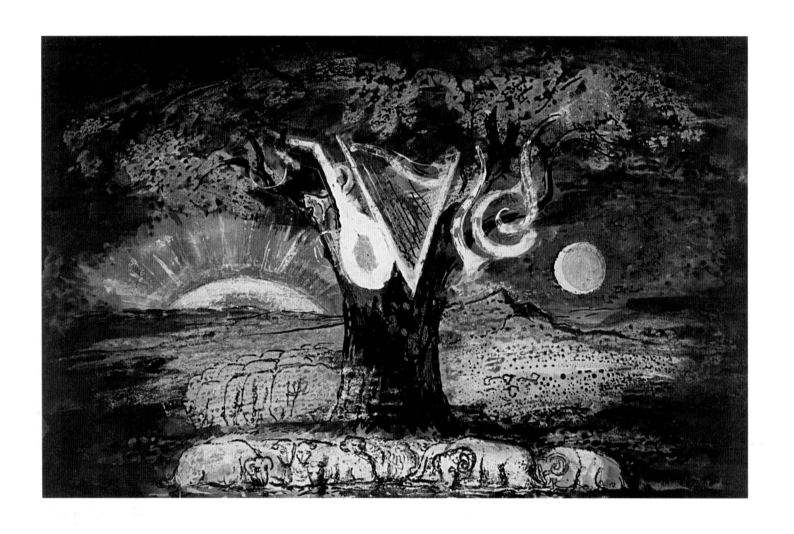

94.
The Earth, scene 1
1948

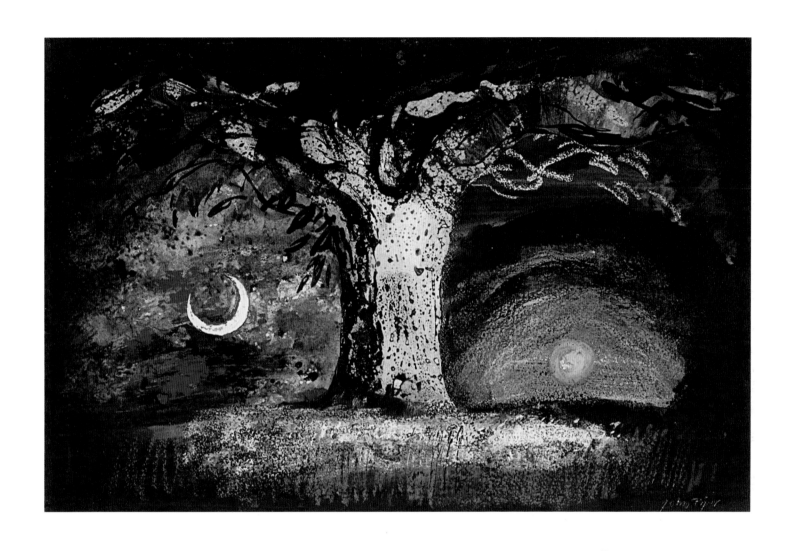

98.
The Earth, scene 8
1948

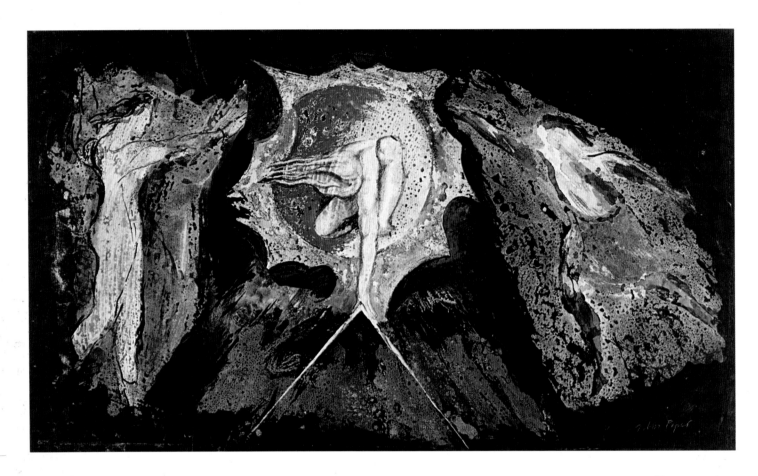

96.
Heaven
1948

97.
Hell
1948

1.
Forms on a Green Ground
1936, oil on canvas, 152.4 × 182.9 cm
Artist's Estate

2.
Brighton Aquatints
Text and twelve aquatints,
introduction by Lord Alfred Douglas.
Duckworth, London 1939
25.8 × 40.0 cm
Gordon Bowyer

3.
Pendine
1938, paper collage, 40.0 × 52.7 cm
Victoria & Albert Museum

4.
Oxon
Collage for endpapers of *Oxon*,
a Shell Guide. B. T. Batsford Ltd,
London, 1938. 30.5 × 50.8 cm
Artist's Estate

5.
Trawsallt, Cardiganshire
1939, watercolour and monotype,
38.1 × 50.8 cm
Private collection

6.
Italian and Gothic, Hafod
1939, watercolour and ink,
38.6 × 52.7 cm
*Lent by The National Museums and
Galleries of Wales*

DESIGNS FOR 'TRIAL OF A JUDGE'
BY STEPHEN SPENDER.
A PRODUCTION BY THE GROUP
THEATRE AT THE UNITY THEATRE
CLUB, MARCH 1938

7.
Design for 'Trial of a Judge'
1938, watercolour, 15.2 × 22.9 cm
Private collection

8.
A Room in the Palace of Justice
1938, watercolour, 23.5 × 32.2 cm
Victoria & Albert Museum

9.
Design for 'Trial of a Judge'
1938, watercolour, 22.9 × 31.8 cm
Private collection

10.
Design for 'Trial of a Judge'
1938, watercolour, 22.9 × 31.8 cm
Private collection

11.
Two Designs for 'Trial of a Judge'
1938, watercolour, 22.8 × 31.7 cm,
21.6 × 31.7 cm
Victoria & Albert Museum

12.
Dead Resort, Kemptown
1939, oil on canvas, 45.7 × 55.9 cm
*Leeds Museums and Galleries
(City Art Gallery)*

13.
*Royal Adelaide: A Simmons House,
Windsor*
1939, oil on board, 49.8 × 60.0 cm
Private collection

14.
The Octagonal Church, Hartwell
1939, oil on canvas , 50.8 × 40.6 cm
*Lincolnshire County Council:
Usher Gallery, Lincoln*

15.
Gethsemene, Cardiganshire
1940, oil on board, 38.1 × 49.5 cm
Save and Prosper Collection

16.
Cheltenham Fantasia
1939, watercolour & collage,
43.2 × 55.9 cm
Cheltenham Art Gallery and Museum

17.
Cheltenham
1940, auto-lithograph
Martin Bowyer

18.
*The Control-room at South West
Regional Headquarters, Bristol*
1940, oil on panel, 63.5 × 76.2 cm
Imperial War Museum, London
OFFICIAL COMMISSION

19.
*The Passage to the Control-room
at South West Regional
Headquarters, Bristol*
1940, oil on panel, 76.2 × 50.8 cm
Imperial War Museum, London
OFFICIAL COMMISSION

20.
The Barn at Great Coxwell
*c.*1941, watercolour, 38.1 × 52.1 cm
Victoria & Albert Museum

21.
Tombstones at Holy Trinity Churchyard, Hinton-in-the-Hedges, Northants, September 1939
1939, watercolour, 40.6 × 54.0 cm
Victoria & Albert Museum

22.
Coventry Cathedral, 15 November 1940
1940, oil on canvas, 76.2 × 63.5 cm
Manchester City Art Galleries
OFFICIAL COMMISSION

23.
Interior of St Michael's Cathedral, Coventry, 15 November 1940
1940, oil on canvas laid on board, 50.8 × 61.0 cm
Herbert Art Gallery and Museum, Coventry
OFFICIAL COMMISSION

24.
St Mary-le-Port, Bristol, November 1940
oil on canvas, 76.2 × 63.5 cm
Tate Gallery. Presented by the War Artists Advisory Committee 1946
OFFICIAL COMMISSION

25.
Church of the Holy Nativity, Knowle, near Bristol
1940, oil on canvas, 61.3 × 50.8 cm
Bristol City Museum and Art Gallery
OFFICIAL COMMISSION

26.
Christ Church, Newgate Street, after its destruction in December 1940
1941, oil on canvas, 76.8 × 64.1 cm
Museum of London
OFFICIAL COMMISSION

27.
The Ruined Council Chamber, House of Commons, May 1941
oil on canvas, 91.4 × 121.9 cm
Palace of Westminster
OFFICIAL COMMISSION

28.
House of Commons 1941: Aye Chamber
1941, oil on canvas on board, 75.7 × 63.5 cm
National Gallery of Canada, Ottawa Gift of the Massey Collection of English Painting, 1946

29.
All Saints Chapel, Bath
1942, watercolour, 41.9 × 55.9 cm
Tate Gallery. Presented by the War Artists Advisory Committee 1946
OFFICIAL COMMISSION

30.
Somerset Place, Bath
1942, watercolour, 48.9 × 76.2 cm
Tate Gallery. Presented by the War Artists Advisory Committee 1946
OFFICIAL COMMISSION

31.
Ruined Victorian House, Lansdown, Bath
1942, watercolour, 43.7 × 56.0 cm
Leeds Museums and Galleries (City Art Gallery)
OFFICIAL COMMISSION

FIVE BLITZED CHURCHES

32.
St Mary-le-Port, Bristol
1940–41, gouache, 18.5 × 14.5 cm
Private collection

33.
Redlands Park Congregational Church, Bristol
1940–41, gouache, 17.5 × 13.5 cm
Private collection

34.
St John's Waterloo Road, London
1940–41, gouache, 18.5 × 12.9 cm
Private collection

35.
The Temple Church, Bristol
1940–41, gouache, 14 × 11 cm
Private collection

36.
Coventry Cathedral
1940–41, gouache, 12.5 × 16.7 cm
Private collection

37.
Sketchbook
1940–41, 18.2 × 16.3cm
Private collection

38.
Holkham, Norfolk
1939–40, oil on canvas, 50.8 × 76.2 cm
Private collection

39.
Valle Crucis Abbey
1940, oil on canvas, 63.5 × 76.2 cm
Private collection, courtesy of Crane Kalman Gallery

40.
Seaton Delaval
1941, oil on canvas, 63.5 × 76.2 cm
Tate Gallery. Presented by Sir Kenneth Clark (later Lord Clark of Saltwood) through the Contemporary Art Society 1946

41.
Lacock Abbey
1942, oil on canvas, 57.2 × 120.7 cm
Lacock Abbey, The National Trust
(bequeathed by Alec Clifton-Taylor,
via NACF)

42.
Rievaulx Abbey
1942, oil on linen, 69.9 × 87.6 cm
lent by Rochdale Art Gallery

DESIGNS FOR 'THE QUEST' BY
SIR FREDERICK ASHTON,
SADLER'S WELLS BALLET AT THE
NEW THEATRE, SHAFTESBURY
AVENUE, APRIL 1943

43.
The Magician's Cave
1943, watercolour, 25.4 × 36.8 cm
Royal Ballet Benevolent Fund

44.
The House of Pride
1943, watercolour, 24.1 × 38.1 cm
Royal Ballet Benevolent Fund

45.
The Place of Rocks near the Palace
of Pride
1943, watercolour, 25.4 × 36.8 cm
Royal Ballet Benevolent Fund

46.
The House of Holinesse
1943, watercolour, 36.8 × 53.3 cm
Royal Ballet Benevolent Fund

47.
Sloth, Wrath and Lechery
1943, watercolour, 53.3 × 91.4 cm
Royal Ballet Benevolent Fund

48.
The Hermaphrodite
1943, watercolour
Royal Ballet Benevolent Fund

49.
Sans Foy
1943, watercolour, 30.5 × 23.5 cm
Royal Ballet Benevolent Fund

50.
Sans Joy
1943, watercolour, 30.5 × 23.5 cm
Royal Ballet Benevolent Fund

51.
Sketch for 'The Quest'
1943, pen & ink & gouache,
12.1 × 20.3 cm
Private collection

52.
Sketch for 'The Quest'
1943, pen & ink & gouache,
24.1 × 31.7 cm
Private collection

53.
Sketch for 'The Quest'
1943, pen & ink & gouache,
12.7 × 21.6 cm
Private collection

54.
Sketch for 'The Quest'
1943, pen & ink & gouache,
31.4 × 24.5 cm
Professor Luke Herrmann

55.
View of Knole
*c.*1942–43, oil on canvas,
53.3 × 76.2 cm
Private collection, courtesy of Spink-Leger

56.
Renishaw, the North Front
*c.*1942–45, oil, 43.2 × 73.7 cm
Sir Reresby Sitwell, Bart

57.
The Lake in Summer, Renishaw
*c.*1942–45, watercolour,
31.8 × 71.1 cm
Sir Reresby Sitwell, Bart

58.
The Arch in the Ravine
*c.*1942–45, watercolour,
53.3 × 68.6 cm
Sir Reresby Sitwell, Bart

59.
View of Windsor town and the
river, and railway from the Curfew
Tower
1942, watercolour, 39.4 × 52.1 cm
From the collection of HRH Queen
Elizabeth, The Queen Mother

60.
The Round Tower from the roof of
St George's Chapel
1942, watercolour, 38 × 59.3 cm
From the collection of HRH Queen
Elizabeth, The Queen Mother

61.
Gothic Ruin, Windsor Great Park
1942, watercolour, 40.5 × 54.8 cm
From the collection of HRH Queen
Elizabeth, The Queen Mother

62.
The town of Windsor from the
Castle
1942, watercolour, 41 × 49.8 cm
From the collection of HRH Queen
Elizabeth, The Queen Mother

63.
Gordale Scar
1943, oil on canvas, 76.2 × 63.5 cm
Private collection

64.
Weathercote Cave
1943, oil on canvas panel,
64.0 × 45.7 cm
lent by the South London Gallery

65.
Two Nudes
*c.*1942, black ink, gouache, water-
colour, wax crayons & pencil,
35.5 × 53 cm
Private collection

66.
Nude
1942, watercolour, 27.3 × 38.1 cm
Tate Gallery. Purchased 1990

67.
Nude Study
1942, watercolour, 27.3 × 38.1 cm
Jonathan Clark

68.
Derelict Cottage, Deane,
Hampshire, March 1941
1941, oil on canvas, 51.1 × 75.9 cm
Leicester City Museum Services

69.
The Cottage by Firth Wood,
Hampshire
1941, oil on canvas, 71.1 × 91.4 cm
Government Art Collection

70.
A Wall at Mulcheney Abbey
1941, oil on canvas, 50.8 × 61.0 cm
The Phillips Collection, Washington, DC

71.
Farmyard Chapel, Trecarrel, near
Launceston
1943, watercolour, 41.9 × 52.1 cm
Private collection

72.
Ruined Cottage, Tomen-y-Mur
1943, oil on canvas, 52.1 × 61.6 cm
Manchester City Art Galleries

73.
'The Bells Go Down'
Design for a film poster (not used)
1942, gouache & ink, 44.1 × 64.4 cm
Imperial War Museum, London

74.
'Painted Boats'
1945, film poster, 76.2 × 101.6 cm
Private collection

75.
'Pink String and Sealing Wax'
1945, 76.2 × 101.6 cm
BFI Collections

76.
Land Reclamation at Swaffham
1944, ink, watercolour & gouache,
39.7 × 64.4 cm
Birmingham Museums & Art Gallery
OFFICIAL COMMISSION

77.
View from West Kennet Long
Barrow
1944, pen and black ink,
watercolour, bodycolour, coloured
crayon, 36.8 × 51.4 cm
Private collection, courtesy of Spink-Leger

78.
Shelter Experiments, near
Woburn, Bedfordshire
*c.*1943–44, watercolour,
44.7 × 68.8 cm
Imperial War Museum, London
OFFICIAL COMMISSION

DESIGNS FOR MURALS AT MERTON
PRIORY BRITISH RESTAURANT

79.
Moonlit Ruins
1942–43, gouache, 31.2 × 61.6 cm
Arts Council Collection, Hayward
Gallery, London

80.
Stained Glass Window Sketch
1942–43, gouache, 48.0 × 48.0 cm
Arts Council Collection, Hayward
Gallery, London

81.
Waverley Abbey
1942–43, gouache, 37.5 × 50.0 cm
Arts Council Collection, Hayward
Gallery, London

82.
Repairing and repainting warships
returning from the beaches
1944, body-colour, watercolour &
black ink, 53.0 × 67.0 cm
Bristol City Museum and Art Gallery
OFFICIAL COMMISSION

83.
American locomotives awaiting
trans-shipment on the foreshore at
Cardiff
1944, pen & ink, pastels, gouache,
watercolour, graphite stick,
56.7 × 70.1 cm
Ferens Art Gallery: Hull City Museums &
Art Galleries
OFFICIAL COMMISSION

84.
Train Ferry at Dover Harbour
1944, watercolour with pen & ink,
58.1 × 72.4 cm
National Maritime Museum, Greenwich,
London
OFFICIAL COMMISSION

85.
Ministry of War Transport
('Empire Creek') in dry dock at
Fowey, Cornwall
1944, watercolour & gouache,
56.1 × 68.6 cm
Leeds Museums and Galleries
(City Art Gallery)
OFFICIAL COMMISSION

86.
The Rise of the Dovey
1944, oil on canvas, 69.9 × 87.6 cm
Private collection

87.
The River Ogwen
1948, oil on canvas, 64.1 × 75.9 cm
Earl of Airlie

88.
In Llanberis Pass
1945–46, watercolour, pen & chalk,
57.8 × 69.9 cm
Arts Council Collection, Hayward
Gallery, London

89.
Cwm Caseg
*c.*1946–48, watercolour, pen and
chalk, 50.8 × 66.0 cm
National Library of Wales, Aberystwyth

90.
Slopes of Glyder Fawr, Llyn Idwal,
Caernarvonshire
1948, watercolour, pen and chalk,
54.6 × 69.9 cm
The Whitworth Art Gallery, University of
Manchester

91.
Glaciated Rocks, Nant Ffrancon
*c.*1946–48, pen, ink and wash,
54.6 × 71.1 cm
Tate Gallery. Purchased with funds
provided by the Helena and Kenneth
Levy Bequest 1991

92.
Ffynon Llugwy
1949, bodycolour, indian ink, wax
crayon, watercolour & chalk,
55.9 × 73.7 cm
The British Council

93.
Snowdonia, North Wales
1945–9, watercolour on paper,
52.1 × 69.2 cm
On loan from Reading Museum and
Archive Service. Purchased with the
assistance of the Museums & Galleries
Commission / Victoria & Albert Museum
Purchase Grant Fund, the National Art
Collection Fund and the Reading
Foundation for Art

DESIGNS FOR 'JOB, A MASK FOR
DANCING', BY NINETTE DE VALOIS
BEING BLAKE'S VISION OF THE
BOOK OF JOB.
SADLER'S WELLS BALLET AT COVENT
GARDEN, MAY 1948

94.
The Earth, scene 1
1948, watercolour, 38.1 × 55.2 cm
Victoria & Albert Museum

95.
Satan Usurps the Throne of
Heaven, scene 2
1948, model, 43.2 × 90.2 × 62.2 cm
Victoria & Albert Museum

96.
Heaven
1948, watercolour, 33.7 × 57.2 cm
Victoria & Albert Museum

97.
Hell
1948, watercolour, 41.3 × 56.5 cm
Victoria & Albert Museum

98.
The Earth, scene 8
1948, watercolour, 40.0 × 56.5 cm
Victoria & Albert Museum

LENDERS

United Kingdom

Aberystwyth, National Library of Wales 89

Birmingham Museums & Art Gallery 76

Bristol City Museum and Art Gallery 25, 82

Cardiff, The National Museums and Galleries of Wales 6

Cheltenham Art Gallery and Museum 16

Coventry, Herbert Art Gallery and Museum 23

Ferens Art Gallery: Hull City Museums & Art Galleries 83

Lacock Abbey, The National Trust 41

Leeds Museums and Galleries (City Art Gallery) 12, 31, 85

Leicester City Museum Services 68

Lincolnshire County Council: Usher Gallery, Lincoln 14

London, Arts Council Collection, Hayward Gallery 79, 80, 81, 88

London, The British Council 92

London, Government Art Collection 69

London, Imperial War Museum 18, 19, 73, 78

London, Museum of London 26

London, British Film Institute 75

London, National Maritime Museum, Greenwich 84

London, Palace of Westminster 27

London, Royal Ballet Benevolent Fund 43, 44, 45, 46, 47, 48, 49, 50

London, Save and Prosper Collection 15

London, South London Gallery 64

London, Tate Gallery 24, 29, 30, 40, 66, 91

London, Victoria & Albert Museum 3, 8, 11, 20, 21, 94, 95, 96, 97, 98

Manchester City Art Galleries 22, 72

Manchester, The Whitworth Art Gallery, University of Manchester 90

Reading Museum and Archive Service 93

Rochdale Art Gallery 42

USA

The Phillips Collection, Washington 70

Canada

National Gallery of Canada, Ottawa 28

Private Collections

5, 7, 9, 10, 13, 32, 33, 34, 35, 36, 37, 38, 51, 52, 53, 63, 65, 71, 74, 86

HRH Queen Elizabeth, The Queen Mother 59, 60, 61, 62

Gordon Bowyer 2

Martin Bowyer 17

Professor Luke Herrmann 54

Sir Reresby Sitwell, Bart 56, 57, 58

private collection, courtesy of Crane Kalman Gallery 39

private collection, courtesy of Spink-Leger 55, 76

SELECT BIBLIOGRAPHY

The following bibliography has been selected from the comprehensive bibliography on Piper and all his works originally compiled by Beth Houghton and Hilary Gresty for the Tate Gallery retrospective in 1983. Post-1983 additions have been selected by the author.

I. BOOKS WRITTEN OR EDITED BY THE ARTIST

Brighton aquatints twelve original aquatints of modern Brighton; with short description by the artist; and an introduction by Lord Alfred Douglas, London: Duckworth, 1939. 12 full-page black and white original aquatints.

British romantic artists: London; Collins, 1942, (Britain in picture series), Re-published in *Aspects of British art*, ed. by W.J.Turner, Collins, 1947.
Buildings and prospects. London: Architectural Press, 1948. Illus. comprise 3 halftones of drawings, 4 halftones of paintings, 1 line drawing and dust wrapper.
Murray's Buckinghamshire architectural guide. [with John Betjeman, Eds.] London: J. Murray, 1948. Dust wrapper designed by Piper.
Murray's Berkshire architectural guide. [with John Betjeman, Eds] London, Murray, 1949. Dust wrapper designed by Piper.
Foreword to *The drawings of Henry Fuseli*, by Paul Ganz London: M.Parirsh, 1949, pp.7–10.

Shell guides, London. Faber and Faber. Since 1938 Piper has been associated with the Shell guides series – as an editor (initially with John Betjeman, later alone), as photographer and illustrator, and as the author of; *Oxfordshire not including the city of Oxford*, Batsford, 1038, reissued Faber and Faber, 1939. *Shropshire*, with John Betjaman, 1951. Wiltshire, with J.H.Cheetham, 1968.

II. ARTICLES AND SECTIONS OF BOOKS BY THE ARTIST

Including those which he both wrote and illustrated. In addition to the articles cited below, which are intended to include all those on painting, sculpture and graphic art, between the late 1920s and 1950s Piper contributed articles, reviews and illustrations to periodicals such as the *Athenaeum, The New Statesman and Nation, The Spectator, Horizon, The Saturday Review, London Mercury, New Leader, House and Garden.*

1937
Pre-history from the air. *AXIS*, no.8, Early Winter 1937, pp.4–8.

1938
The nautical style. *Architectural Review*, Jan. 1938, (vol.83), pp.1–14, plus 1 plate, (photos by Piper and J. M. Richards).
English sea pictures. (Art). *The Listner*, 28 July 1938, pp.180–1.
Abstraction on the beach. *XXe Siècle*, Jul./Aug./Sept. 1938, (1ère année, no.3), p.41.

The art of the early crosses. *Country Life*, 28 Aug. 1938, pp.218–9.
Henry Fuseli, R. A. 1741–1825, *Signature*, no.10, Nov. 1938, pp.1–14, plus 4 leaves of plates.
Architectural deportment: [reviews of A miniature history of the English house', by J.M. Richards, and 'Pillar to post', by O.Lancaster], *The New Statesman and Nation*, 10 Dec 1938, p.1000, 1002.
Notes on wall objects old and new. *Decoration*, no.30, Winter 1938, pp.39–43.

1939
London: l'architecture londonienne depuis 1800. *Cahiers d'Art*, 1939, (vol.14, nos 1–4), pp.92–103.
Curwen Press News-Letter, no.16, 1939. 3 colour lithograph design by Piper on cover.
London to Bath: a topographical and critical survey of the Bath road: [written and illus. by Piper]. *Architectural Review*, May 1939, (vol.85), pp.229–46.
Barbarous Wales: [review of 'Welsh life in the eighteenth century' by Sir L. Twiston Davies and R. Edwards]. *The New Statesman and Nation*, 9 Dec 1939, p.868, 870.
From 1 Dec. 1939–26 May 1944 John Piper wrote regularly for *The Spectator* as their art critic.

1940
Grey tower and panelled pew: John Piper looks at English country churches and makes drawings of them specially for *The Listener, The Listener*, 1 Feb. 1940, pp.216–8,(4 illus.)
Fully licensed;[in praise of the ordinary public house]. *Architectural Review*, Mar. 1940,(vol.87), pp.87–100, (illus. incl. Photos by Piper).
Decrepit glory: a tour of Hafod. *Architectural Review*, June 1940, (vol.87), pp.207–10, plus 1 plate, (6 illus. by Piper).
Round the art exhibitions. *The Listener*, 6 June 1940,p.1100
The art of the stuccador, *The Listener*, 5 Sept. 1940, p.353.
Towers in the Fens. *Architectural Review*, Nov. 1940, pp.131–4, plus 2 plates, (illus. incl. 8 photos by Piper).

1941
John Piper at the A.A. ... [extracts from a paper entitled 'Buildings in English art']. *Architect and Building News*, 9 May 1941, (vol.166), p.85, (2 illus. by Piper).
The Euston Road Group. *The Listener*, 29 May 1941, pp.771–2.
Victorian painting. *The Listener*, 20 Nov. 1941, p.698. [2 illus. by Piper: 'Buckland House'; 'Towcester – screen to Racecourse']. *Architect and Building News*, 19 Dec. 1941, (vol.168), pp.170–1.

1942
S. H. Grimm: watercolour painter,(Art). *The Listener*, 12 Mar. 1942, p.341.
John Sell Corman, 1782–1842. *Architectural Review*, July 1942, (vol 92), pp.9–12.
Notes from a Yorkshire journal. *The Geographical Magazine*, Dec. 1942 p.364–367.

1943
Foreword to the catalogue *The artist and the Church*, organised by C.E.M.A., London, 1943, pp.3–4, *see also* group exhibitions, (353)
Stanley Spencer, *Britain Today*, Jan. 1943, (no.81), p.24.
A Cubist folk art. *Architectural Review*, July 1943, (vol.94), pp.21–2, (5 drawings by Piper; photos incl. Some by Piper).
Colour reproduction and the cheap book (Art). *The Listener*, 22 July 1943, p.104
The gratuitous semicircle. *Architectural Review*, Oct. 1943, (vol.94), pp.112–3, (illus. incl. 7 drawings by Piper).
Some old friends. (Colour in building series). *Architectural Review*, Nov.1943, pp.139–41, (illus. incl. 7 drawings by Piper).
Colour and display. (Colour in building series), *Architectural Review*, Dec 1943, (vol.94), pp.168–71, (illus. incl. 9 drawings by Piper).

1944
Colour and texture. (Colour in building series). *Architectural Review*, Feb. 1944, (vol.95), pp.30, 51–2.
Blandford Forum.(Colour in building series). *Architectural Review*, July 1944, (vol.96), pp.21–3, (illus. incl. 11 drawings by Piper).
Warmth in the west. *Architectural Review*, Sept. 1944, (vol.96), pp.89–91, (illus. incl. 8 drawings by Piper).
Topographical letter from Norwich (illustrated with notes for painting). *The Cornhill Magazine*, Jan. 1944, (vol.161, NO.961), pp.9–18 plus[4]p. of plates, 8 line drawings, 4 pen and wash.
Flint. *Architectural Review*, Nov.1944, 9 vol., 96), pp.149–51, (illus. incl. 7 illus. by Piper).
Topographical letter from Devizes. *The Cornhill Magazine*, Nov.1944, (vol.161, no.963), pp.190–5 plus [4]p of plates, 4 line drawings in text, 4 col. lithos.

1945
Seaton Delaval. *Orion: a miscellany*, no.1, 1945, pp.43–47.
The English tradition of draughtsmanship. *The Listener*, 8 Feb.1945.
Shop. Architectural Review, Mar. 1945, (vol.97), pp.89–91, (3 illus. by Piper).
Colour in the picturesque village, *Architectural Review*, May 1945, (vol.97), pp.130, 149–50, (6 illus. by Piper).
Renaissance Britain. (Art). *The Listener*, 26 July 1945, p.104.
St. Marie's Grange: first home of A.W.N. Pugin,. *Architectural Review*, Oct. 1945, (vol.980, pp.90–3, (2 illus. by Piper).
Introduction to Middlesbrough, *Cornhill Magazine*, Dec. 1945, (vol.161, no.966), pp.430–3 plus [4]p. of plates, (1illus. from a watercolour by Piper).
Coloured pictures. *The Listener*, 6 Dec. 1945, pp.663–4

1946
A wool country: colour in the Corswolds. *The Ambassador*, 1946, (no.5), pp.61–72, (10 illus. by Piper, plus cover design).

Georgian London. (Art), *The Listener,* 28 Mar.1946, p.408.

Exeter replanned;[review of 'Exeter phoenix' by T. Sharp]. *The New Statesman and Nation,* 20 Apr. 1946, pp.288–9.

The market square. (Colour in building series). *Architectural Review,* May 1946, (vol.99), pp.153–5, (4 illus. by Piper).

The artist and the Church. *Cymry'r Groes; a Quarterly Magazine,* July 1946, (vol.2, no.1), pp.25–32.

Religion inspires a modern artist: [on Graham Sutherland's 'Crucifixion' in the Church of St.Mathew, Northampton]. *Picture Post,* 21 Dec. 1946, pp.13–15.

1947

Post-Reformation sculpture: [review of 'English church monuments', 1510–1840, by K.A. Esdaile]. *The New Statesman and Nation.* 8 Mar. 1947, p.160.

Pleasing decay, *Architectural Review,* Sept. 1947, (vol.102), pp.85–94.

Sickert: painter-critic. *The Listener,* 4 Sept. 1947, p.396.

English painting at the Tate: [exhibition review] *Burlington Magazine,* Oct. 1947, (vol.890, p.285.

A new Bath guide. *The Listener,* 27 Nov. 1947, p.946.

1948

'Designs of Lucretia', p.67 in The Rape of Lucretia: a symposium; ed. By Ronald F.H. Duncan; with texts by Benjamin Britten, Ronald Duncan, John Piper *et al,* London: Bodley Head, 1948. Also contains 8 colour lithographs form the original designs by Piper, most full page 3, fold out to 15" wide, 1 reproduced on the front wrapper.

Design for 'The Quest', *Britain Today,* Apr. 1948, (no.144),1 illus. facing p.39.

Pattern and colour from English slate engravings; collected, coloured and described by John Piper. *The Ambassador,* 1948, (no.9), pp.67–89, 950 illus.).

Bath, Edinburgh and art historians.(Art). *The Listener,* 1 July 1948, p.28.

Job: a masque for dancing – set designs, *Britain Today,* Oct. 1948. (no.148), 2 illus. facing p.37.

1949

Foreword to *The drawings of Henry Fuseli,* by Paul Ganz, London: M.Parrish, 1949, pp.7–10.

Book illustration and the painter – artist. *Penrose Annual,* vol.43, pp.52–4, plus 4p. of tipped-in lithographs from illus. by Piper, (6 illus.).

S. John Woods, (Portrait of the artist, no.12). *Art News and Review,* 16 July 1949, (vol.1., no.12), p.1.

Stonehenge. (Reassessment, 50 *Architectural Review,* Sept.1949, (vol.106), pp.177–82, (illus. incl. 7 photos by Piper).

III. BOOKS, ARTICLES AND PAMPHLETS ILLUSTRATED BY PIPER

John Betjeman. *The seeing eye,* or *How to like everything;* illus. by John Piper. *Architectural Review,* Nov. 1939, (vol.86), pp.201–4, (8 illus.).

Horizon, Jan.1940, (vol.1, no.1). Cover design by Piper.

C. Day Lewis. *Poems in wartime.* London: J. Cape, 1940. Illus. on the cover and title page reproduced from drawings by Piper.

John Betjeman and Geoffrey Taylor, *English, Scottish and Welsh landscape, 1700–c.1860;* chosen by John Betjeman and Geofrey Taylor; with original lithographs by John Piper, London: F.Muller, 1944. 12 Full-page colour autolithographs, and front and back cover lithograph.

Rev .Francis Kilvert. *Kilvert's diary, 1870–1879; selections from the diary of the Rev. Francis Kilvert;* chosen, ed. and introd. By William Plomer. London: Redears Union, J.Cape, 1944. Frontis and decoration on title page from drawings by Piper.

Palinurus. *The unquiet grave: a word cycle...* Rev. ed. London: H. Hamilton, 1945. Front dust wrapper designed by Piper, printed from collage original at the Curwen Press.

Sir Osbert Sitwell. *Left hand, right hand;* [an autobiography in 5 volumes]. London: Macmillan, 1945–50. vol.1: *Cruel month* (1945); vol.2: *The Scarlet tree* (1946); vol.3: *Great Morning* (1948); vol.4: *Laughter in the next room* (1949); vol.5; *Noble essences* (1959). Illus. with reproductions of Piper's paintings and drawings.

Sir Thomas Browne. *The last chapter of Urne buriall;* [ed. By John Carter], Cambridge: Will Carter at the Rampant Lions Press, 1946. Ltd. ed. of 175 copies. Cover and title page designs by Piper.

Walter de la Mare. *The traveller;* with drawings by John Piper, London: Faber and Faber, 1946. 6 colour drawings by Piper, lithographed by T.E. Griffits at the Baynard Press.

Myfanwy Evans (ed.) *The pavilion contemporary collection of British art and architecture.* London: I.T. Publications, 1946.

2 copies of medieval stained glass window by Piper, lithographed by T. Griffits, pp.15–17.

James M. Richards. *The castles on the ground;* illus. by John Piper. London: Arcfiitectural Press, 1946. 8 full-page two-colour autolithographs incl. Frontis. Dust wrapper design three-colour lithograph. See also 2nd ed, 1973.(180).

Norman Hancock. *An innocent grows up.* London; J.M.Dent, 1947. Colour lithographed dust wrapper and frontis. From same collage original.

Michael Sadleir. *Forlorn sunset.* London: Constable, 1947. 2-colour lithographed front dust wrapper and frontis. From same original.

Evelyn Waugh, *Scot-Kings modern Europe,* London: Chapman and Hall, 1947. Dust wrapper design by Piper.

Geoffrey Grigson. *An English farmhouse and its neighbourhood,* London: M.Parrish, 1948.(Studies in composition and tradition series, ed. By John Piper). Double-spread cover design by Piper.

John Piper, *Buildings and prospects,* 1948, *see* Books by...(5)

William Sansom, *South: aspect and images from Corsica, Italy and Southern France,* London; Hodder & Stoughton, 1948. Front dust wrapper designed by Piper.

Sir George R.Sitwell. *On the making of gardens:* with an introduction by Sir Osbert Sitwell; and decorations by John Piper, London; Dropmore

Press, 1949. Ltd ed. Of 1,000 copies. 6 colour line illus.: 3 full-page; 3 double spreads.

John Betjeman and John Piper (Eds.). *Murray's Berkshire architectural guide,* 1949. *see* Books by...

IV. INTERVIEWS WITH THE ARTIST

B. Myerscough-Walker. Modern art explained by modern artists: B. Myerscough-Walker interviews John Piper who explains his views and general outlook on art. (Part III). *The Artist,* May 1944, (vol.27, no.3), pp.65–7.

The Arbitrary Eye: A Photographic Discourse between John Pier and Paul Joyce, in *British Journal of Photography,* 25 Nov 1983, pp.1239–43

VI. ONE-MAN EXHIBITIONS

1933
London, Zwemmer. No catalogue.

1938
May, London, London Gallery, *John Piper: Paintings, collages and drawings* (31 works). In *London Gallery Bulletin,* no.2, 1938, pp.9–[12]. Introduction by Paul Nash.

1940
March. London, Leicester Galleries, *Paintings and watercolours* by John Piper.(35 works) 8p.

1945
Jan. London, Leicester Galleries. *The Sitwell country: Derbyshire domains, backgrounds to an autobiography* (47 works). pp.18–20. Preface by Sir Osbert Sitwell, Bart.

1946
Oct.–Nov. London, Leicester Galleries, *John Piper: stage designs for Benjamin Britten's opera 'The Rape of Lucretia',* (23 works).[4]p.

1948
Feb. New York, Buchholz Gallery, John Piper. (43 works). Introd. By John Piper.[8]p.
Dec. London , Leicester Galleries. *New paintings and drawings* by John Piper. (39 works). 19p.

1949
Nov.–Dec. London, Victoria and Albert Museum. *Special exhibition of paintings by John Piper commissioned for the British Embassy in Rio de Janeiro.* (5 works). [no catalogue traced].

1964
Mar. London, Marlborough New London Gallery. *Retrospective exhibition: John Piper.* (137 works). 38p. Pref. By Robert Melville.

1967
March–April. Belfast, Ulster Museum. *John Piper Retrospective.* (121 works), [20]p. Travelling to Marlborough Fine Arts, London and Richard Demarco Gallery, Edinburgh. Introduction by A. Reichardt.

1979

May–June. Oxford, Museum of Modern Art. *John Piper: 50 years of his work: paintings, drawings and photographs, 1920–1979.* (90 works). Texts by J.Hoole, S. Mason, J.Betjeman, H. G. Porteous, J. Piper. 48p. Arts Council exhibition, Travelling to Colchester, The Minories. June–July

Post 1983

Dec. 1983–Jan. 1984, Olympus Gallery, *John Piper: the romantic landscape – photographs 1936–1983.*

July, The Cathedral, Lichfield, *Piper's Churches.*

Dec. 1984, Marlborough Gallery, New York, *John Piper, paintings and watercolours.*

March – April 1985, Buckinghamshire County Museum, Aylesbury, *John Piper's Stowe: an exhibition of watercolours.*

Sept.–Oct. 1987, Marlborough Fine Art, *John Piper: Georgian Arcadia – an exhibition to mark the Golden Jubilee of The Georgian Group*

June–July 1988, Waddington Galleries, *John Piper.*

Dec. 1988–Jan. 1989, Williamson Art Gallery and Museum, Birkenhead, *John Piper: A birthday tribute to celebrate... John Piper's 85th birthday.*

May 1990, Davies Memorial Gallery, Newtown, *John Piper in Wales.*

June–Aug. 1992, Ashmolean Museum, Oxford, *John Piper, the Robert and Rena Lewin Gift to the Ashmolean Museum.*

Dec 1992–Jan 1993, Berkeley Square Gallery, *Piper's Country.*

Feb.–April 1993, Pallant House, Chichester, *John Piper and the Stage.*

Jan.–Feb. 1994, Waddington Galleries in association with James Kirkman, *John Piper, A Retrospective, Works from the Artist's Studio.*

Dec. 1994–Feb 1995, Berkley Square Gallery, *John Piper, From his studio.*

July 1996, Spink, *John Piper, early oils and watercolours.*

Summer 1997, The Stables Gallery, Renishaw Hall, *John Piper at Renishaw.*

April–May 1999, Henry Dyson Fine Art, University of Durham Grey College, Durham, *John Piper: A Retrospective.*

April–Sept. 1999, The Stables Gallery, Renishaw Hall, *John Piper at Other Places.*

Feb.–March 2000, John Martin Galley, *John Piper: Landscapes 1942–85.*

March–July 2000, River and Rowing Museum and Bohun Gallery, Henley, *John Piper, master of diversity.*

VII. SELECTED GROUP EXHIBITIONS

1937

[Jan]. London, Thos Agnew. *An exhibition of paintings in connection with a scheme to provide a permanent gallery for the constant display of works contemporary painters and sculptors.* (3 works).[4] .

March. London, Leicester Galleries, *The London Group; exhibition of works by members,* (1 work). 12p.

Apr.–May, London A.I.A. (41 Grosvenor Sq.), *An exhibition; unity of artists for peace, democracy and cultural development,* (4 works), [15]p.

May, Edinburgh, Fine Art Society at Minto House. *Second annual exhibition of modern art.* (2 works). Introduction By Eileen Holding.

July, London, London Gallery. *Exhibition of constructive art.* (2 works). Introduction by J.L.M [art in] and S. Giedion. [8]p.

Oct.–Nov. London, New Burlington Galleries. *The London Group: 36th exhibition.* (2 works).

Nov.–Dec., London, London Gallery. *Surrealist objects and poems* (2 works), [20]p. and [8] leave plates.

1938

May–June. Guildhall. *Realism and Surrealism: an exhibition of several phases of contemporary art.* (3 works), 36p. Introduction By Herbert Read.

Sept.–Oct. London, Leicester Galleries. *Lithographs in colour: published by Contemporary Lithographs Ltd* (2 works), [8]p.

Nov.–Dec. London, The Cooling Galleries. *Paintings, drawings and sculpture specially chosen for their suitability as Christmas presents by the London Group,* (1 work), [8]p.

Nov–Dec. Paris, Salon d'Automne. *L'Art anglais. Independent contemporain* (2 works).

1939

Jan.–Feb. London, London Gallery, *Living art in England,* (1 work). Catalogue in *The London Bulletin,* no 8–9, Jan.–Feb.1939, pp.57 plus 1 plate p.[36].

May–June, London, Tate Gallery. *Mural painting in Great Britain 1919–1939,* an exhibition of photographs. (1 work), 20p. 11p. of plates.

Oct.–Nov. London, Leicester Galleries. *Selected paintings, drawings and pottery lent by The Contemporary Art Society,* 91 work), 18p.

1940

Jan–Feb. London, Alex Reid & Lefevre, *Art of today: same trends in British painting.* (2 works). [4]p.

June–July, London Alex Reid & Lefevre, *Modern English painting, recent works.* (7 works).

1941

July–Sept. Leeds, Temple Newsam. *Works by Henry Moore, John Piper, Graham Sutherland.* (43 works). Foreword by Philip Hendy, 23p.

A selection from this exhibition then used as a touring C.E.M.A. exhibition, 1941–42.

Oct. London, National Gallery. *War pictures at the National Gallery.* Booklet with foreword by Eric Newton.

1941–2

London, Council for the Encouragement of Music and the Arts. *[Selection from the 1941 Temple Newsam exhibition],* arranged by The British Institute for Adult Education for C.E.M.A., touring Leicester, Harrogate, Brighton and Wakefield. (21 works), [16]p.

1942

London, National Gallery. *War pictures at the National Gallery.* Booklet with foreword by Eric Newton. London, Ministry of Information. *War drawings by*

British artists: an exhibition of original drawings and enlarged photographs of drawings and paintings of war subjects circulated by the Ministry of Information for exhibition in schools. First selection, (1 work). [20]p.

Mar.–May. London, London Museum. *New movements in art, contemporary work in England; an exhibition of recent painting and sculpture.* (2 works). 4p.

1943

London, Council for the Encouragement of Music and the Arts. *The artist and the Church,* (15 works) 4 copies, 11 photographs), 15p. Foreword by John Piper.

Oct.–Nov. London, Royal Academy. *The London Group: fifth war-time exhibition,* (1 work), 12p.

1943–44

London, Council for the Encouragement of Music and the Arts. *Exhibition of ballet design.* (8 works), 14p.

1944

London, Ministry of Information. *War pictures by British artists: an exhibition of official war pictures ... circulated by arrangement with the Museums Association, Fourth selection,* (1 work), [12]p.

Jan. London, Redfern Gallery, *French and English paintings* (7 works). [4]p.

1945

Paris, 28 Avenue des Champs Elysèes. *Quelquers contemporains Anglais.* (4 works) 12p. Organised by the British Council.

Mar.–Apr. New York, Buchholz Gallery. *Contemporary British artists: Ivon Hitchens, Henry Moore, Paul Nash, John Piper* (5 works), [12]p.

Oct.–Nov. London, Royal Academy. *Exhibition of National War Pictures* (13 works) 55p.

1946

Buffalo, Albright Art Gallery. *British contemporary painters* (7 works). Introd. By A.C. Ritchie 97p.

London, Arts Council. *British painting 1939 10 1945* (4 works), 12p.

1974

Aug.–Sept. Edinburgh, Scottish Arts Council. *Art then; eight English artists, 1924–40* (8 works). Catalogue and introduction by David Baxandall. [48]p.

1981–82

Oct. 1981–Jan 1982. London, Imperial War Museum. *Neo-Romantic watercolours* (1 work), [2]p.

Feb.–Mar. Cambridge, Kettle's Yard *Circle: constructive art in Britain, 1934–40,* (2 works), 88p. Text by J. Beckett, N. Bullock, J. Gage, L. Martin.

1982–83

Johannesburg, Art Gallery, *John Piper and English Neo-Romanticism.* (11 works). Introduction by Peter Cannon-Brookes. Organised by the 1820 Foundation in association with the National Museum of Wales, the South African National

Gallery and Zimbabwe National Gallery, Travelling in South Africa.

1983

July–Aug. London, Fischer Fine Art. *The British Neo-Romantics, 1935–1950.* (7 works), 40p. Organised in conjunction with the National Museum of Wales.
Landscape in Britain 1850–1950, Arts Council of Great Britain, Hayward Gallery and tour, 1983, (2 works), 172p.

Post 1983

A Paradise Lost, The Neo-Romantic Imagination in Britain 1935–55, Barbican Art Gallery, May–July 1987
Nine Neo-Romantic Artists, Albemarle Gallery, June–July 1988
The Sitwells and the Arts of the 1920s and 1930s, National Portrait Gallery, Oct 1994–Jan 1995, (6 works), 240p.

VIII. BOOKS AND SECTIONS IN BOOKS ABOUT THE ARTIST ALPHABETICALLY BY AUTHOR

Betjeman, John, *John Piper.* Harmondsworth: Penguin Books, 1944
Circle: international survey of Constructive art; ed. by J.L. Martin, Ben Nicholson, N.Gabo, London: Faber and Faber, 1937. Piper paintings illus. plates 25, 26.
Graham, Rigby, *Romantic book illustration in England 1943–1955.* Pinner (Mddx): Private Libraries Association, 1965.
Hewison, Robert, *Under siege, literary life in London 1934–45.* London. Weidenfield and Nicholson, 1977. Passim.
Ironside, Robin. *Painting since 1939.* London: British Council, 1947. Passim.
Newton, Eric. *War through artists' eyes.* London: John Murray, 1945, pp.78, 85.
Ross, Alan. *Colours of war art 1939–45,* London; Jonathan Cape, 1983, p.50–52.
West, Anthony, *John Piper.* London: Secker and Warburg, 1979.
Woods, S. John, *John Piper: paintings, drawings and theatre designs 1932–1954,* London: Faber and Faber: New York: Curt Valentin, 1955. Contains 1 aquatint and 4 autolithographs produced for the book.

Post 1983

Elborn, Geoffrey, ed., *To John Piper on his eightieth birthday,* London, Stourton Press, 1983
Mark L Evans, *The Derek Williams Collection at the National Museum of Wales,* Cardiff, National Museum of Wales, 1989
Fuller, Peter, *Images of God, The Consolations of Lost Illusions,* London, Chatto & Windus, 1985
Garlake, Margaret, *New Art World, British Art in Postwar Society,* Yale, Yale University Press, 1998
Green, Candida Lycett, ed., John Betjeman, *Letters, 1, 1926–1951,* London, Metheun, 1994, London Minerva, 1995.
Green, Candida Lycett, ed., John Betjeman, *Letters, 2, 1951–1984,* London, Metheun, 1996, copyright 1995.

Geoffrey Grigson, *Recollections, Mainly of Artists and Writers,* London, Chatto and Windus, Hogarth Press, 1984.
Harrison, Charles, *English Art and Modernism 1900–1939,* second edition, London, Michael Joseph, 1994.
Ingrams, Richard and Piper, John, *Piper's Places, John Piper in England and Wales,* London, Chatto and Windus, Hogarth Press, 1983.
Levinson, Orde, *John Piper: The Complete Graphic Works. A Catalogue Raisonne 1923–1983,* London, Faber & Faber, 1987.
Levinson, Orde, *'Quality and Experiment': the Prints of John Piper. A Catalogue Raisonné 1923–91,* London, Lund Humphries, 1996.
Mellor, David, Saunders, Gill and Wright, Patrick, *Recording Britain, A Pictorial Domesday of pre-war Britain,* Newton Abbot, David & Charles, 1990.
Piper, John, *A Painter's Camera, Buildings and Landscapes in Britain 1935–1985,* London, Tate Gallery, 1987.
Sillars, Stuart, *British Romantic Art and the Second World War,* London, Macmillan, 1991.
Sinclair, Andrew, *War Like a Wasp, The Lost Decade of the 'Forties',* London, Hamish Hamilton, 1989.
Stansky, Peter, *London's Burning; Life, Death and Art in the Second World War,* London, Constable, 1994.
Yorke, Malcolm, *The Spirit of Place, Nine Neo-Romantic Artists and Their Times,* London, Constable, 1988.

IX. SELECTED PERIODICAL AND NEWSPAPER ARTICLES ABOUT THE ARTIST

1946

Nelson Lansdale. The Old Vic brings new art; [set designs for 'Oedipus']. *Art News,* May 1946, (vol.45, no.3), pp.48–9, 69.

1947

H.A. Cronache: Londra: Una mostra di John Piper, *Emporium,* Feb. 1947, (vol.105, no.626), p.85.

1948

Stuart Preston. Spotlight on: Koerner, Piper [and other artists]; [review of 1948 one-man exhibition at Buchholz Gallery], *Art News,* Feb.1948, (vol.46, no.12), pp.29,49.
Judith Kaye Reed, Piper, Modern English; [review of the 1948 one-man exhibition at the Buchholz Gallery]. *Art Digest,* 15 Feb, 1948, (vol.22,
Stage design. *Vogue,* Sept. 1948, pp.86–7, 110, 112, 116.

1949

Romantic opera 1949;[Piper's sets for the New York production of the 'Rape of Lucretia']. *Art News,* Jan. 1949, (vol.47, no.9), p.24.
Philip Hendy, [review of 1948 one-man exhibition at Leicester Galleries] in English watercolours. *Britain Today,* Feb.1949, (no.154), pp.37–40.
Geoffrey Grigson, John Piper's England. *The Listener,* 28 Apr. 1949, p.724.
S. John Woods, John Piper as a topographical illustrator. *Image: a quarterly of the visual arts,* no.2, autumn 1949, pp.3–18.

C[hristopher] H[ussey], Murals for Rio de Janeiro by John Pier at the Victoria and Albert Museum; [review of 1949 one-man exhibition at the V&A]. *Country Life,* 2 Dec. 1949, (vol.1060), pp.1649–50.
Myfanwy Piper. Back in the thirties. *Art and Literature,* 7, winter 1965, p.136.

1976

Sarah Griffiths. War paintings: a no-man's land between history and reportage. *Leeds Arts Calendar* No.78, 1976, pp.24–32, (includes notes on Piper 'M.O.W.T vessel in dry dock at Fowey', p.30, 2 illus. p.26).

1981

Robert Medley. The Group Theatre 1932–39. *London Magazine,* Jan 1981, (vol.20, no.10), pp.47–60.

Post 1983

D. Fraser Jenkins, John Piper and subjects in Wales, The Transactions of the Honourable Society of Cymmrodorion, 1984, pp.317–330
Virginia Button, Modern Britain – 40 Years On, *Galleries,* July 1986, pp.12–13
Peter Fuller, British Art: An Alternative View, *Art and Design,* 3, 1987, pp.55–66
Malcolm Yorke, English New-Romantics, *Art and Design,* 4, 1988, pp.36–41
Tanya Harrod, The mapping of a gone and pleasant land, *Independent on Sunday Magazine,* 5 Aug 1990
John Piper: A Catalogue of Books, Ridware Books, June 1990
Geoff Mason Apps, The night hell came to Coventry, *Independent on Sunday,* 11 Nov 1990, p.12
Patrick Wright, Signs of the Horrid Tendency Here, and David Mellor, The Topography of Disappearance, Modern Painters, winter 1990–1, pp.38–41
Antony Griffith, Contemporary Lithographs Ltd, *Print Quarterly,* Dec. 1991, pp.388–402
John Piper, Obituaries: *The Times,* and leader 'Through English Eyes', 30 June; *The Independent,* 30 June and 2 July; *Daily Telegraph* 30 June, 1992.
Tony Reichardt, John Piper – A Personal View; Michael Sellers, A Day with John Piper; S John Woods, A Man of Many Parts; John Commander, John Piper – Master of All, *Labrys,* Nov 1993, pp.3–80.
Colin Gleadell, Vintage Piper, *Galleries,* Jan 1994, p.12.
Maggs Bros Ltd and George Baynton, Books from the library of John and Myfanwy Piper, catalogues 1240–2, 1997–8.